San Antonio's Spanish Missions: A Portrait

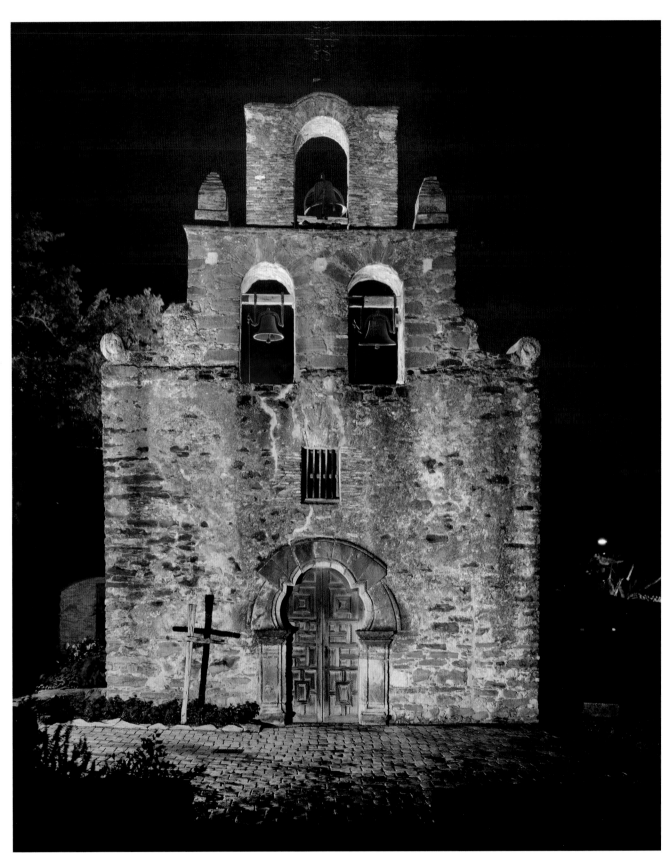

The facade of Mission Espada's chapel, built in the 1750s, features
an unusually shaped arched entry of Moorish or Visigothic design.

SAN ANTONIO'S SPANISH MISSIONS: A PORTRAIT

PHOTOGRAPHS
BY MIKE OSBORNE

Text by Lewis F. Fisher
Foreword by Rev. David Garcia

MAVERICK PUBLISHING COMPANY

MAVERICK PUBLISHING COMPANY
P. O. Box 6355, San Antonio, Texas 78209

Library of Congress Cataloging-in-Publication Data

Osborne, Mike, 1978–
San Antonio's Spanish missions : a portrait / photographs by Mike Osborne ;
text by Lewis F. Fisher ; foreword by David Garcia.
p. cm.
ISBN 978-1-893271-52-4 (alk. paper) – ISBN 978-1-893271-53-1 (alk. paper)
1. Missions–Texas–San Antonio–Pictorial works.
2. Spanish mission buildings–Texas–San Antonio–Pictorial works.
3. Architecture–Texas–San Antonio–Pictorial works.
4. San Antonio (Tex.)–Pictorial works. I. Fisher, Lewis F. II. Title.
F394.S21143O833 2009
726.509764'3510222–dc22

2009027041

Book and cover design by Janet Brooks / janetbrooks.com

Printed in China

CONTENTS

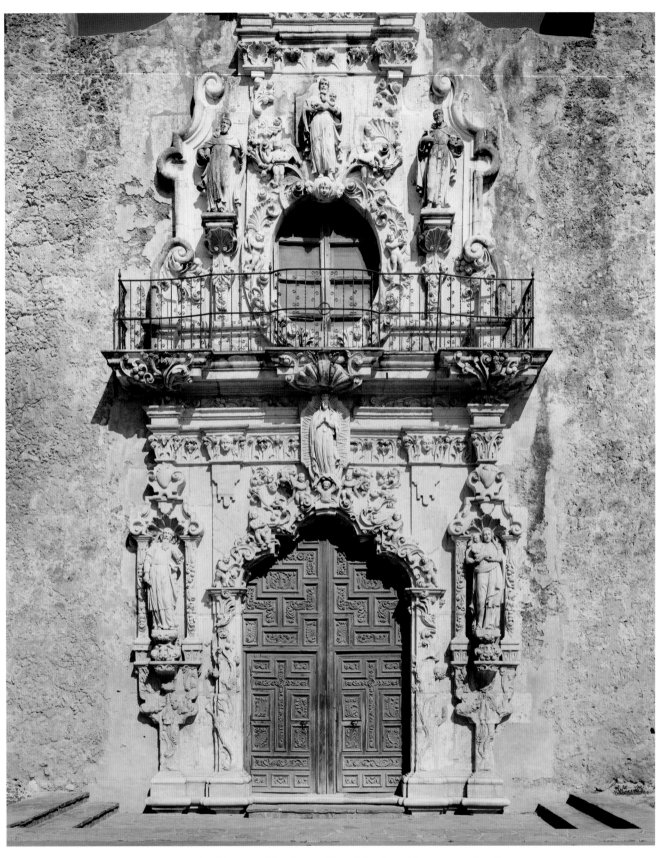

Some authorities consider the quality of the Spanish Baroque facade
of Mission San José's church to be unrivalled in the United States.

FOREWORD

All Americans can be proud of the magnificent old Spanish missions of San Antonio. They are more than just buildings constructed on the northern edge of New Spain nearly three centuries ago. They are reminders of the imagination and inspiration of the human spirit. The missions' churches and chapels engage us in wonder and invite us to reflect on the countless numbers of people who have entered the hallowed walls for prayer, worship, and inspiration, and on the timeless beauty and deep symbolism that are so much a part of these buildings.

A leading stonemason who directed much of the recent stonework on the Cathedral of St. John the Divine in New York City recently spent several days doing close inspection of the carved facade of the church of Mission San José. Amazed at the level of artistry and detail that went into each figure and decoration, he proclaimed it the work of a master stonemason. He marveled that this level of excellence could have been achieved in what was then one of the farthest outposts of the Spanish empire.

In his opinion the carved facade at San José is unrivalled in this country, and takes its place among the great decorative fronts of the famous churches of the world.

Under the agreement that created San Antonio Missions National Historical Park in 1983, the National Park Service owns and maintains the outlying buildings and grounds of four missions and the Catholic Archdiocese of San Antonio owns and maintains the four mission churches and chapels, although the entire religious community of San Antonio can rightfully claim these worship centers as part of their heritage as well. The successful collaboration has resulted in a level of visitors that now exceeds 1.5 million a year.

To cement their commitment the Archdiocese maintains the position of Director, Old Spanish Missions, which presently I am privileged to hold. We are dedicated to preserving these wonderful churches as living churches, not simply as museums or snapshots of a past time but rather as the settings for a continuing panorama of the lives and times of the people who have kept them so vibrant.

Let these photographs tempt you to visit these special places and return many times.

Fr. David Garcia
Director, Old Spanish Missions
Catholic Archdiocese of San Antonio

When S. E. Jacobson took this photo of a mother scrubbing clothes on a washboard beside a Spanish aqueduct about 1890, he casually named the aqueduct for the nearest old mission, San Juan. In fact, the ancient aqueduct was built to carry an acequia over the creek with water for the more distant Mission Espada. Next to erecting a place worship, building a water system was the top priority for Franciscan missionaries on the semiarid northern frontier of New Spain.

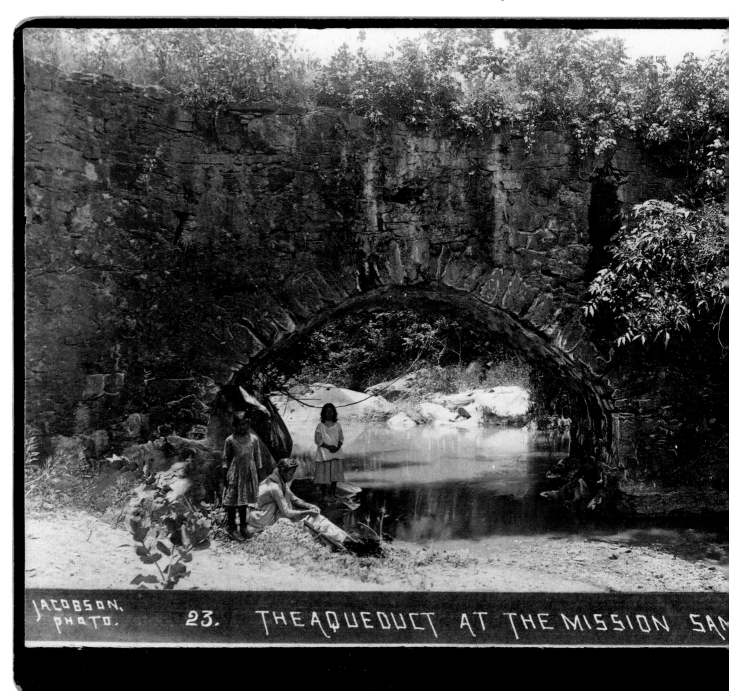

JACOBSON, PHOTO. 23. THE AQUEDUCT AT THE MISSION SAN

INTRODUCTION

Even after their founding purpose of Europeanizing Native Americans ended, San Antonio's Spanish missions have held a fascination for visitors and residents alike.

Railroads building westward in Texas promoted the missions as a destination for tourists. The crumbling remains were increasingly visited in horse and carriage, then by automobile and tour bus. There became even more to see as fallen walls and roofs were put back in place, and as old mission plazas were reclaimed. Four mission churches and chapels

regained functioning congregations, and in the last quarter of the twentieth century became focal points of San Antonio Missions National Historical Park. The fifth, by then better known as the Alamo, remains in the custody of the Daughters of the Republic of Texas as a shrine to its defenders in 1836.

San Antonio's five Spanish missions form the largest such cluster in the United States. San Antonio de Valero—the Alamo—was established in 1718 with the city of San Antonio, then seen as a way station in the empty frontier between the supply posts of northern New Spain on the Rio Grande and struggling missions far to the north and east along the hostile frontier with the French in Louisiana. A second mission, San José, was established near San Antonio in 1720. Eleven years later three other missions—Concepción, San Juan and Espada—sought refuge from the unstable Louisiana border in new homes along the San Antonio River.

The Texas missions were intended not only to Christianize small native tribes of hunter-gatherers but to teach them to live in the manner of Europeans—to make textiles, to herd goats, to sleep in beds that had legs. Then they were to become the settlers of new European-style towns throughout the frontier and become buffers against the French. Though having to deal with the ravages of epidemics and the tendency of native converts to wander off, San Antonio's missions managed to function and grow, with varying degrees of success. They fell short of supplying populations of new towns, but by the late eighteenth century the threat of the French had receded anyway.

As was the plan had the missions been fully successful, San Antonio's mission complexes, by 1824, were all closed. Their extensive lands were sold. Title to the churches and chapels alone remained with the Roman Catholic Church. There were, however, no viable adjacent communities to support the old mission churches as independent parishes. Jurisdiction went

to the nearest parish church, San Fernando in downtown San Antonio. But its parishioners had difficulty enough maintaining their own church, much less running five more with few if any congregants.

Left to decay during the political and social upheavals in Texas during the middle half of the nineteenth century, San Antonio's missions somehow survived in recognizable form. Partly restored, partly still in ruins, they remain as eloquent testimony to the faith and determination of their founders.

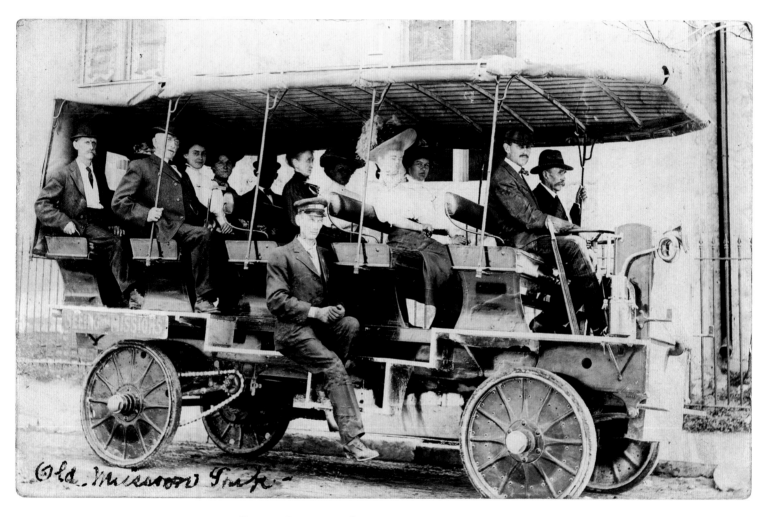

"Seeing the Missions," as announced on the sign below the rear seat, was the goal of this group preparing to leave downtown San Antonio in March 1912. Judging from the solid rubber tires, it was going to be a bumpy ride. This souvenir photo postcard was mailed by the lady at far right in the next to last seat, a dotted veil falling from her hat, to her young daughter back home in Wichita, Kansas.

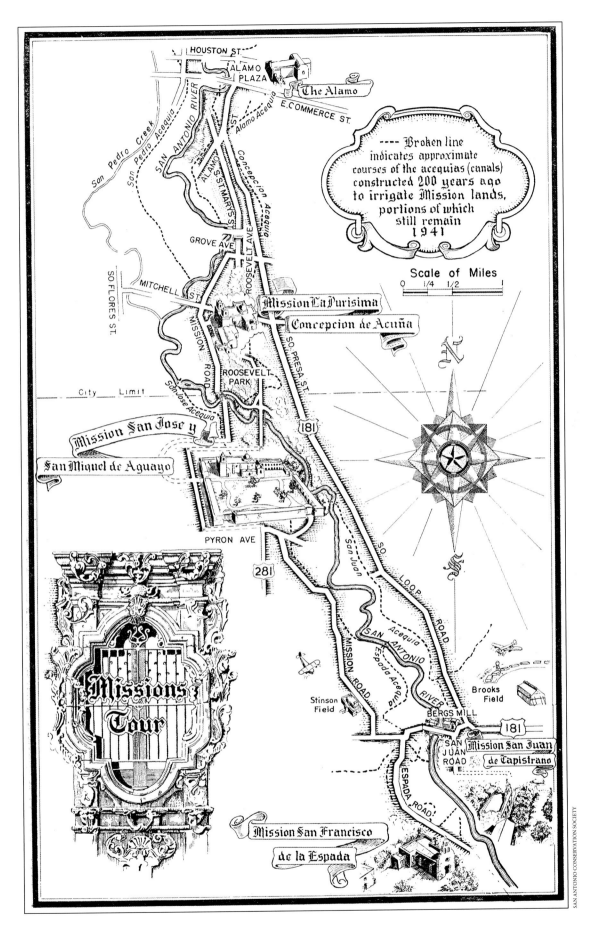

By the time this map was published in a Work Projects Administration guidebook in 1941, paving had smoothed the winding roads to the missions, and Mission San José was newly restored and open as a state park.

1

MISSION SAN ANTONIO DE VALERO / THE ALAMO

Prior to being sold to the state for preservation, the Alamo was leased by the Catholic Church to the U.S. Army for use as a supply depot. This stereoview showing a covered wagon loading up at the main entrance, the American flag flying overhead, was published by San Antonio photographer Henry Doerr about 1868.

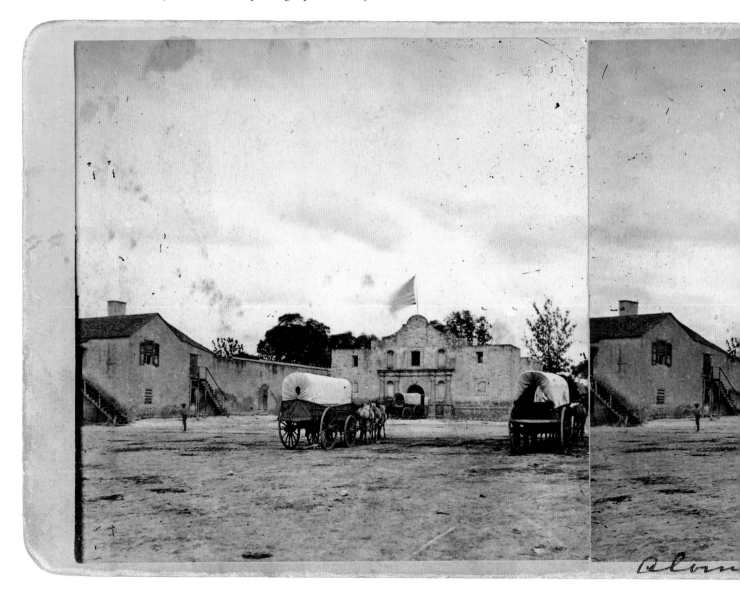

1

MISSION SAN ANTONIO
DE VALERO / THE ALAMO

Few American landmarks are as instantly recognizable as the Alamo. Annihilation of its Texan defenders by a much larger Mexican force on March 6, 1836 made the Alamo a worldwide symbol of bravery and sacrifice in the face of overwhelming odds.

The familiar image is the old mission church, left uncompleted by the Spanish friars. A wooden roof and the now-familiar gabled parapet were added by the U.S. Army in 1849 and a more appropriate vaulted roof seven decades later, after the Alamo had come under the custody of the Daughters of the Republic of Texas.

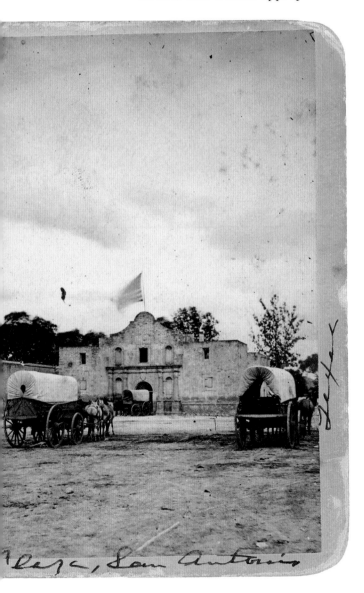

This is the third local site for the old mission, which first was established near the Rio Grande but moved north with the founding of San Antonio on May 1, 1718 to become Mission San Antonio de Valero. The new name was a tribute to the viceroy who had approved the move, the Marqués de Valero.

After the mission closed in 1793 its walls housed a Spanish cavalry garrison from Alamo de Parras, south of the Rio Grande. The troop became known as the Alamo Company, its post as the Alamo. While almost overwhelmed by its military heritage and by its latter-day urban setting, excavations and restorations increasingly lend the careful viewer a coherent sense of the Alamo's origins as a frontier Spanish mission.

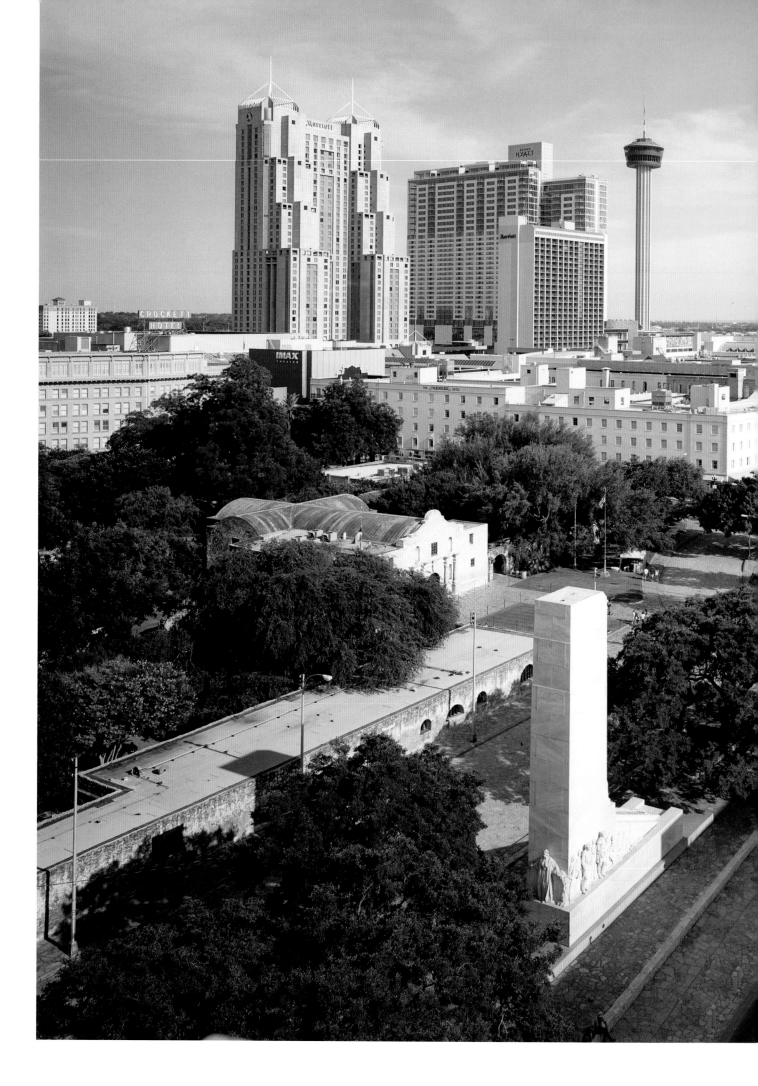

High-rise hotels and the Tower of the Americas now form a backdrop for the former Mission San Antonio de Valero. North Alamo Street at right runs just inside the onetime west wall of the mission compound. The compound's southern boundary ran past the far wall of the church. Angling off the view at lower left is what remains of the mission convento, the former church above it. The cenotaph at lower left center memorializes Texans killed in the 1836 battle on the site.

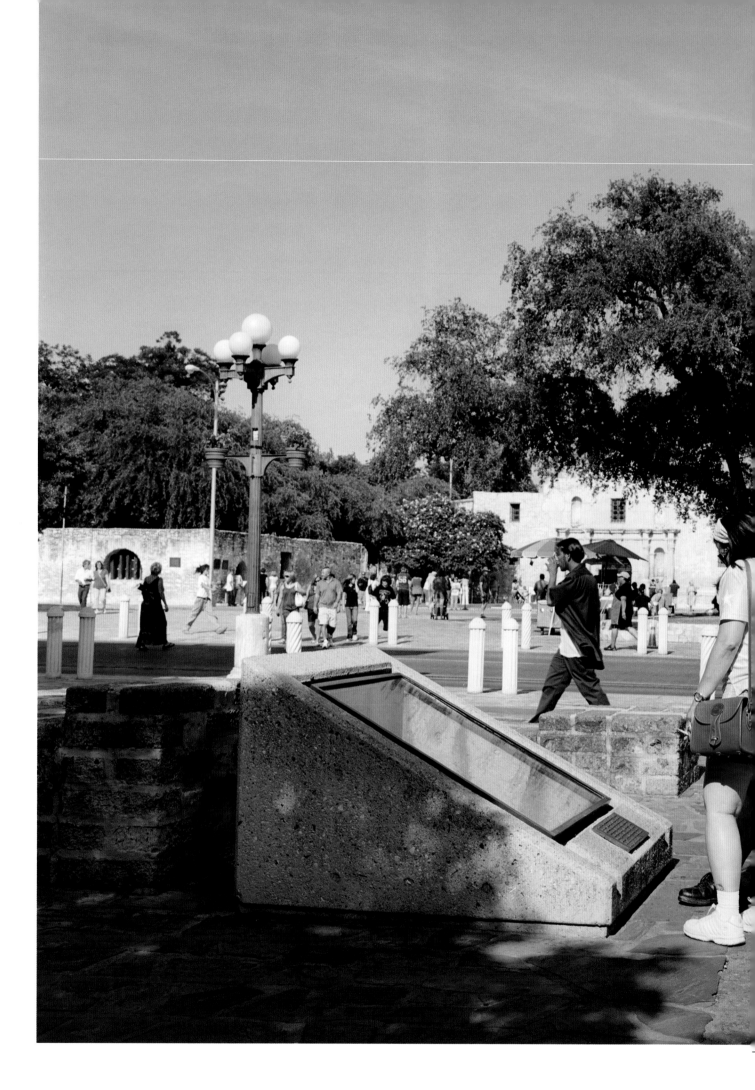

Remains of Mission San Antonio de Valero's west wall have been excavated at the site in the foreground. The visible walls are replicated on the original site of quarters for the mission Indians. Authentic remains of original walls, below the level of the street, can be viewed through glass.

On the northern boundary of the original Alamo grounds is the United States Post Office and Courthouse, left, dedicated by President Franklin Roosevelt in 1937, and the Medical Arts Building, built in 1926 and now the Emily Morgan Hotel.

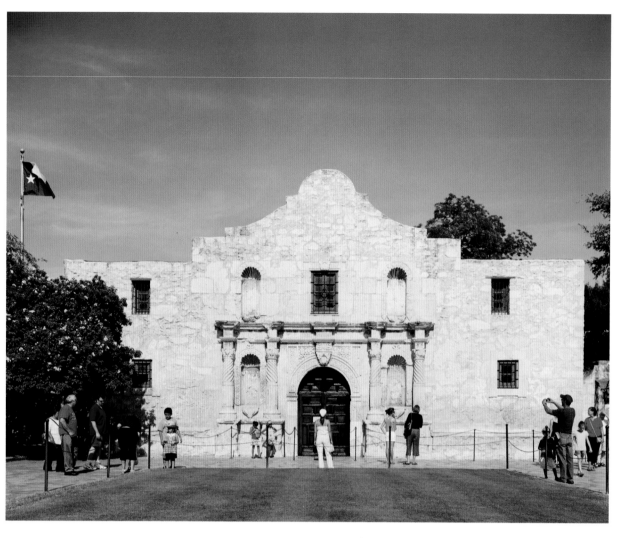

The Alamo remains the top tourist destination in Texas. The mission church was begun in 1744 but never finished above its intended lower level.

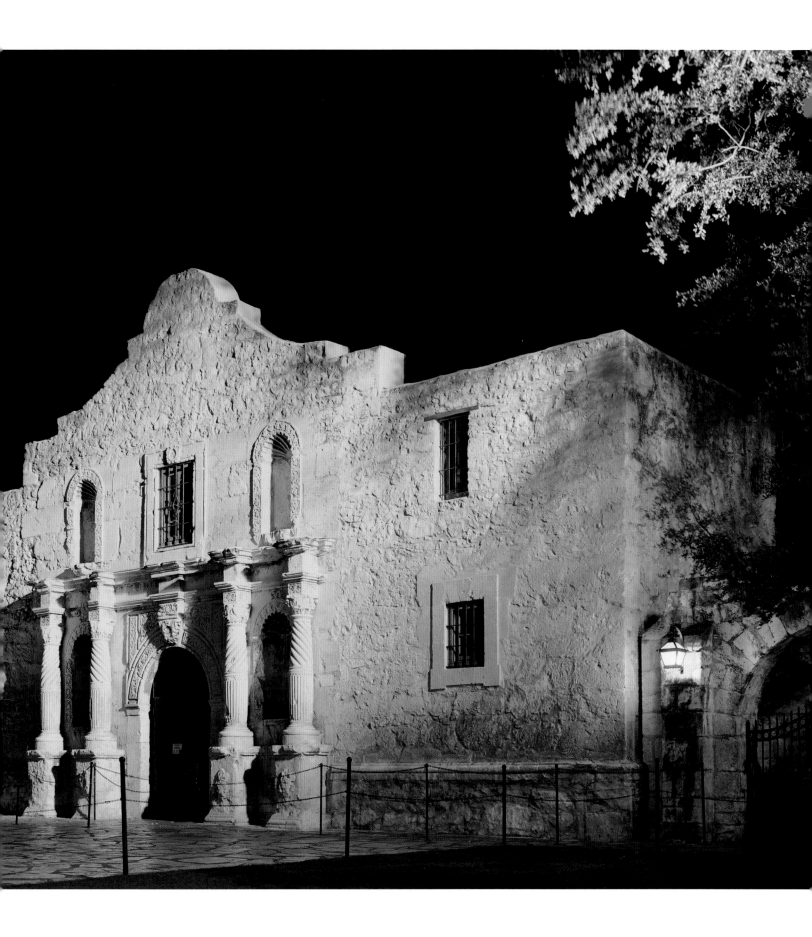

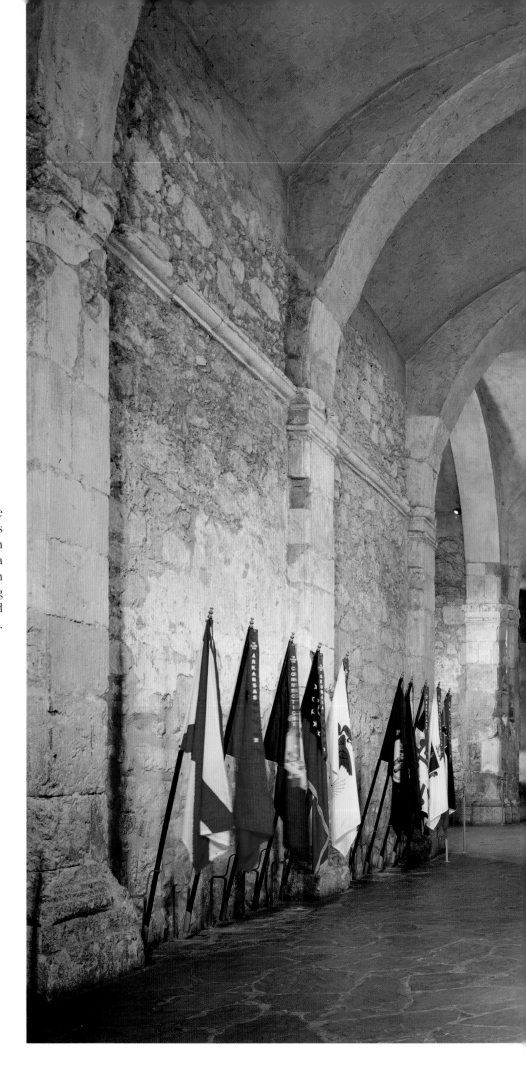

A vaulted roof of reinforced concrete was added atop the mission church's mid-seventeenth century walls in 1920, forming the main hall of a shrine to Texans killed at the site in 1836. Flags along the wall are among those representing home states and nations of defenders.

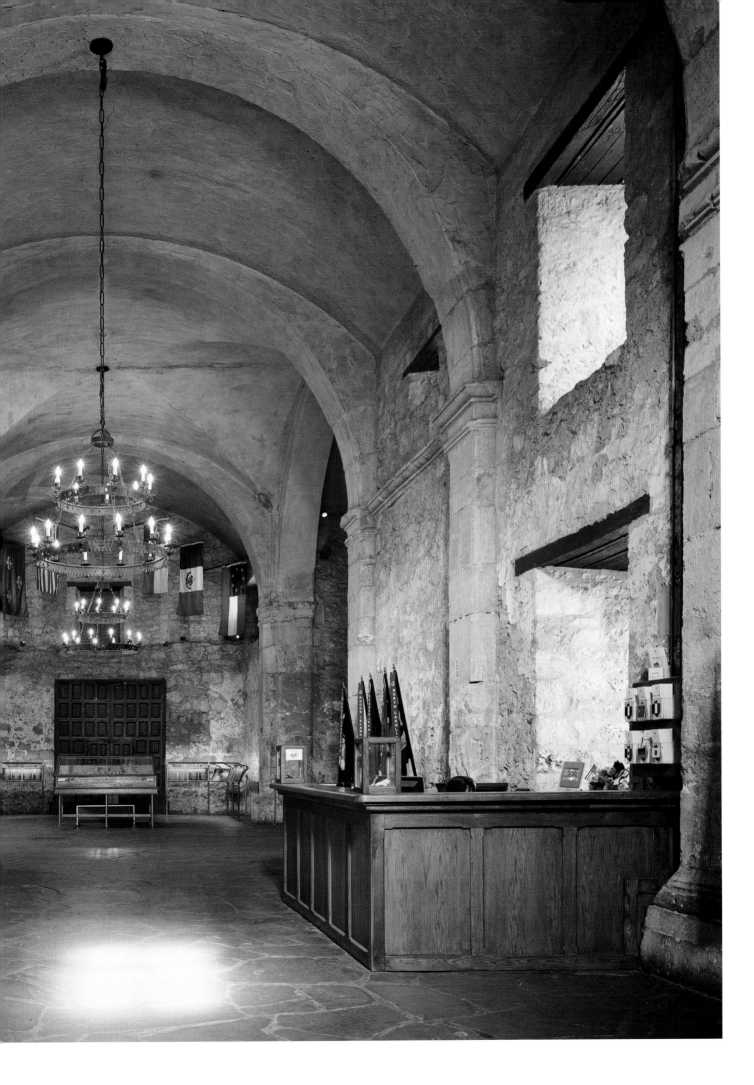

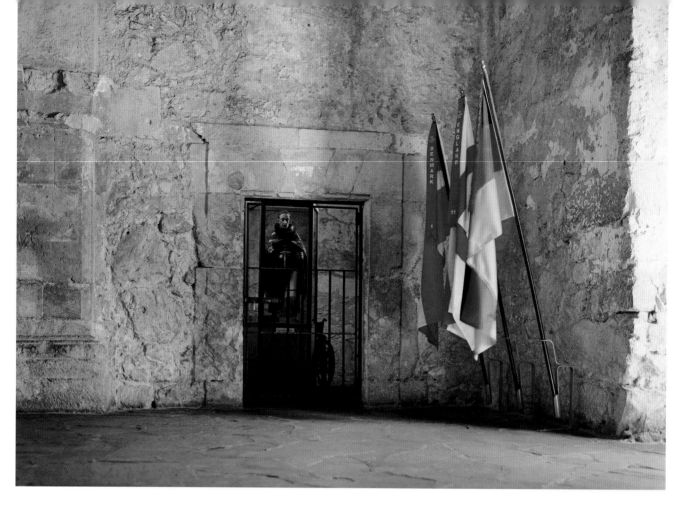

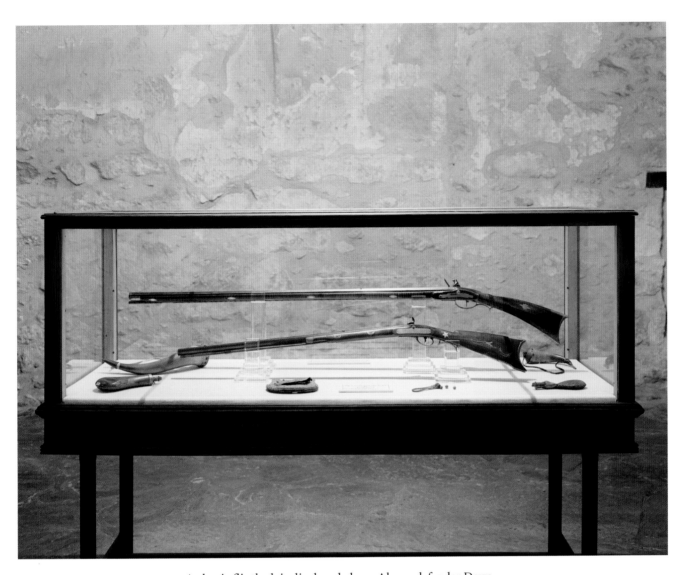

A classic flintlock is displayed above Alamo defender Davy Crockett's "Old Betsy." Originally a long rifle, its barrel was later shortened. Crockett left the rifle with a son when he departed for Texas in 1835.

On the facing page, a statue of Saint Anthony stands in the baptistry of the former mission church. Below, the doorway at left leads from the former sacristy into the north transept.

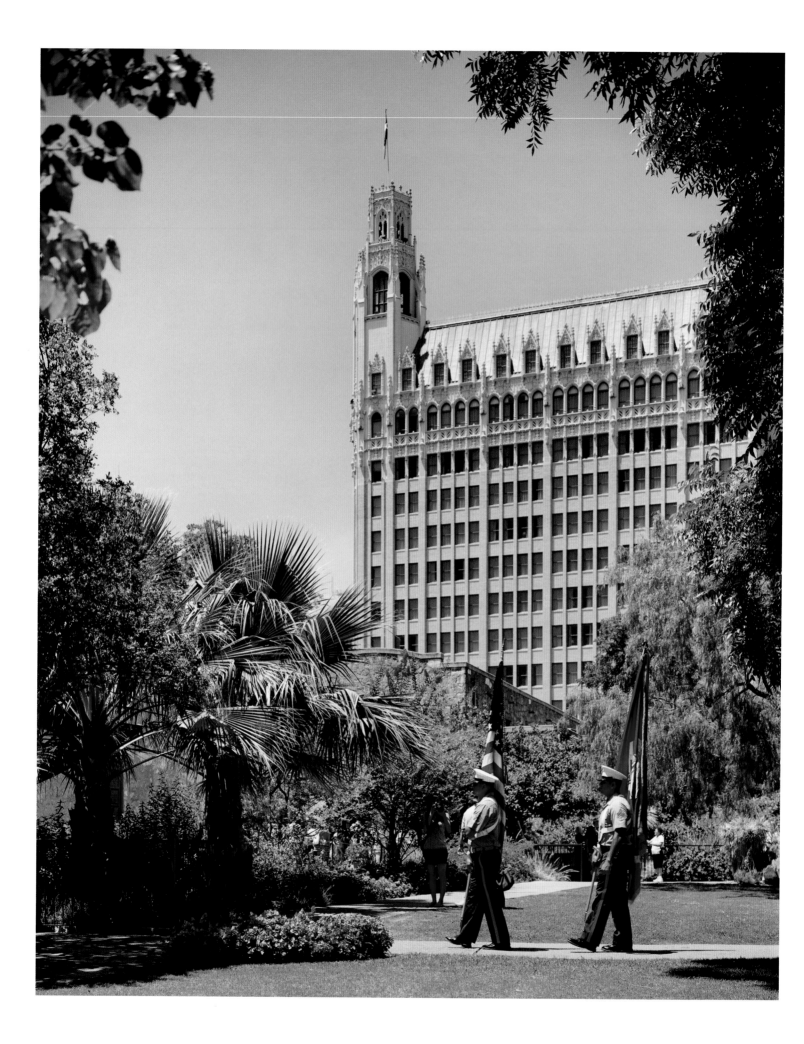

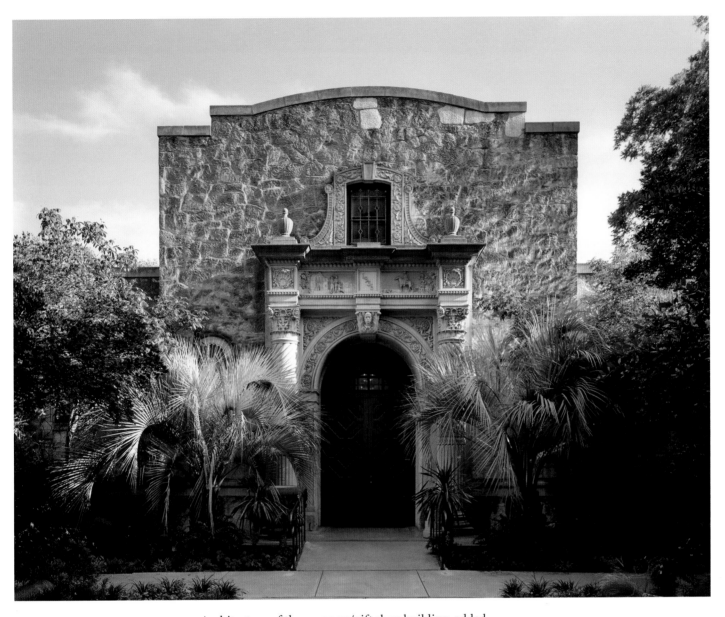

Architecture of the museum/gift shop building, added
with the expansion and improvements following the Texas
centennial in 1936, reflect the mission's original style, above.

The carefully manicured grounds of the old mission now
echo to the footsteps of color guards, left.

2

MISSION CONCEPCIÓN

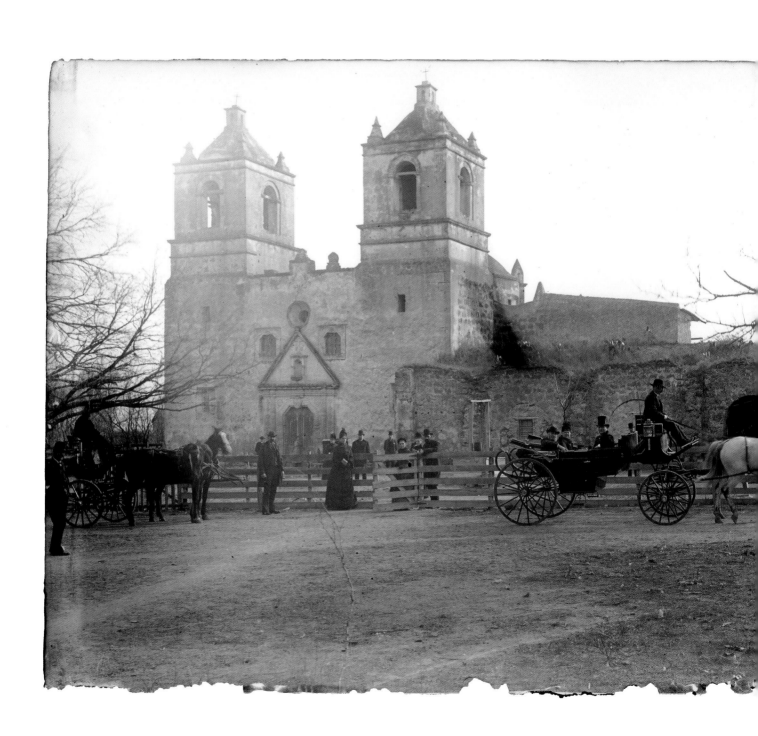

2

MISSION CONCEPCIÓN

San Antonians by the beginning of the twentieth century were referring to Mission Concepción as the "First Mission," since it was the first of the four missions reached when heading south from downtown. Concepción was actually among the three last missions established in San Antonio, having moved in 1731 with two others from troubled East Texas.

Originally named Nuestra Señora de la Purísima Concepción de los Hainais for its location in the homeland of the Hanai tribe, in San Antonio the appendage was replaced with "de Acuña" to honor the viceroy who permitted the move. As the number of Indians living within mission walls sometimes exceeded two hundred, Concepción was also headquarters for one of the two original groups of Spanish missions in Texas.

Concepción's site is closer to bedrock than those of the missions to the south. The resulting stability of the foundations of the church, dedicated in 1755, helped make it the only completed Spanish-era church in the United States not to have needed rebuilding. Unmoving walls have also preserved large portions of Spanish-era frescoes, some still being painstakingly uncovered beneath thick layers of whitewash.

Concepción was used to house military troops even before it closed in 1824. A few decades later the Catholic Church used the mission as headquarters for a farm, and built an orphanage and seminary nearby. Fulltime use of the church resumed in 1913.

By the 1880s Concepción's mission walls had disappeared and outbuildings were in varying stages of decay, but the well preserved mission church, a two-mile carriage ride from town, was drawing a steady stream of visitors. This image was made on a glass photographic negative, its emulsion now peeling slightly around the edges.

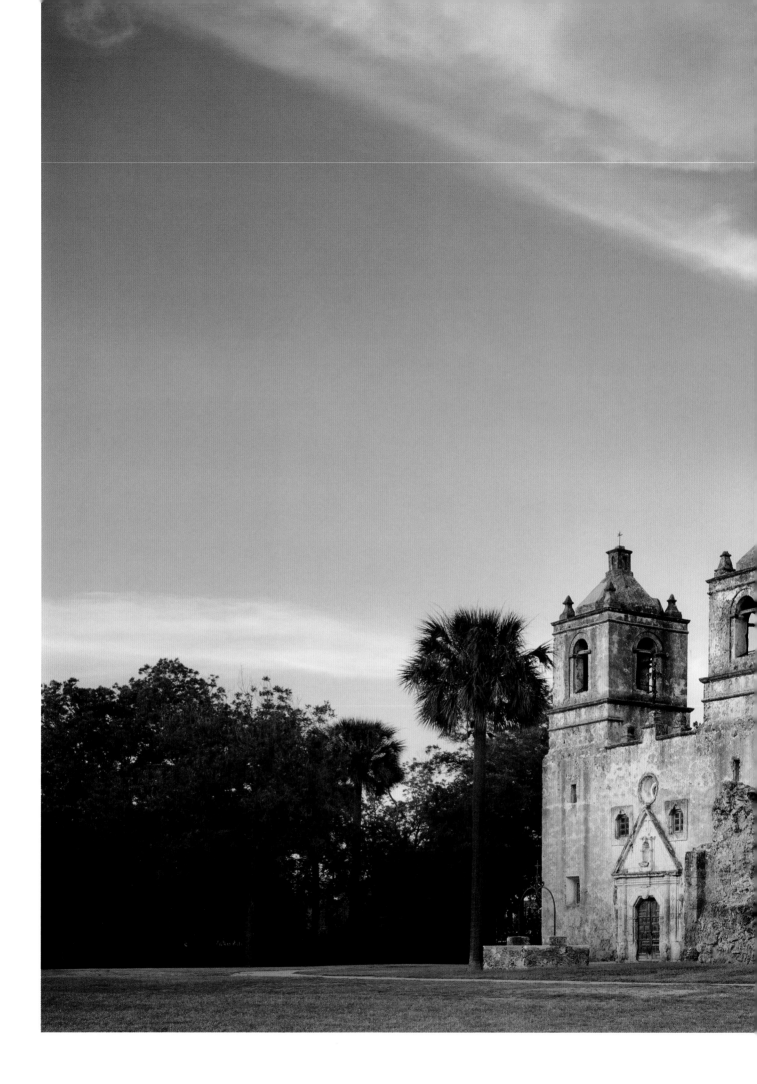

Alone among Spanish-era churches in the United States, that of Mission Concepción has required no major rebuilding since its dedication, on December 8, 1755.

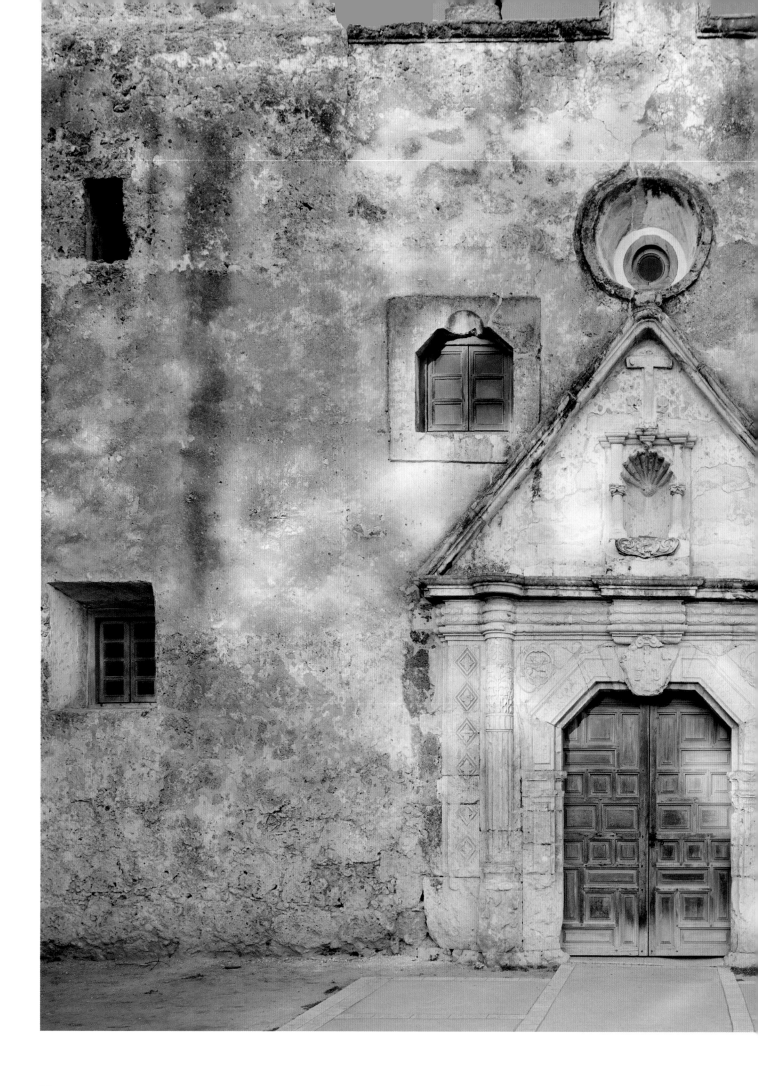

Originally covered in patterns of brightly colored geometric designs, the mellowed stone facade of the mission church is noted for the distinctive design of its entry, crowned by a nearly equilateral stone triangle.

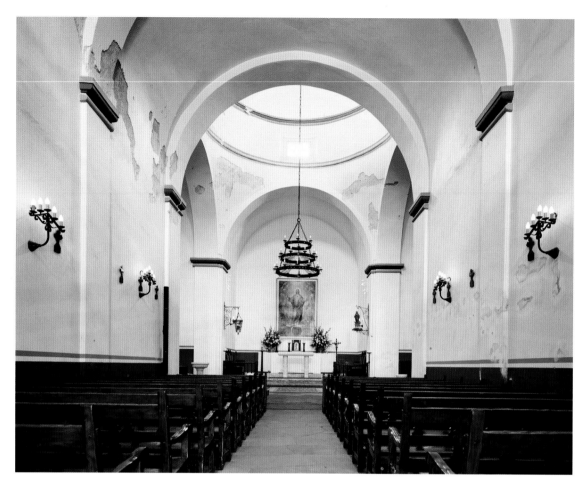

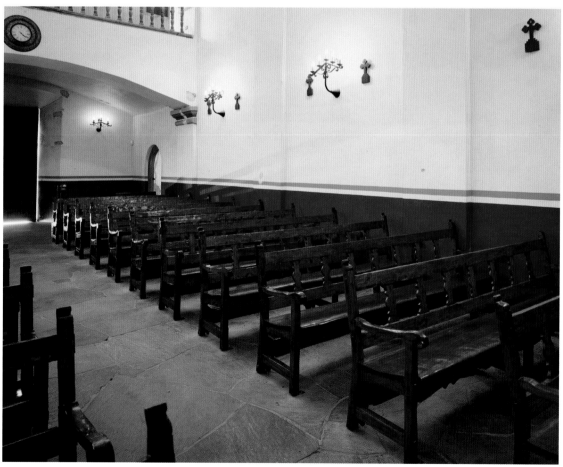

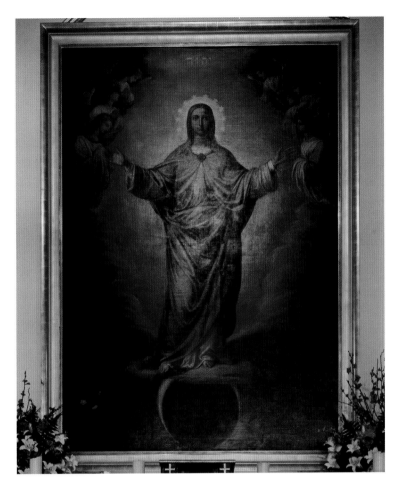

Light from the cupola atop the dome bathes the altar area in a warm glow. Above the altar, the painting of the Immaculate Conception, restored in 2001, is believed to have hung in the church during Spanish times. Probes through layers of whitewash are revealing traces of original fresco designs.

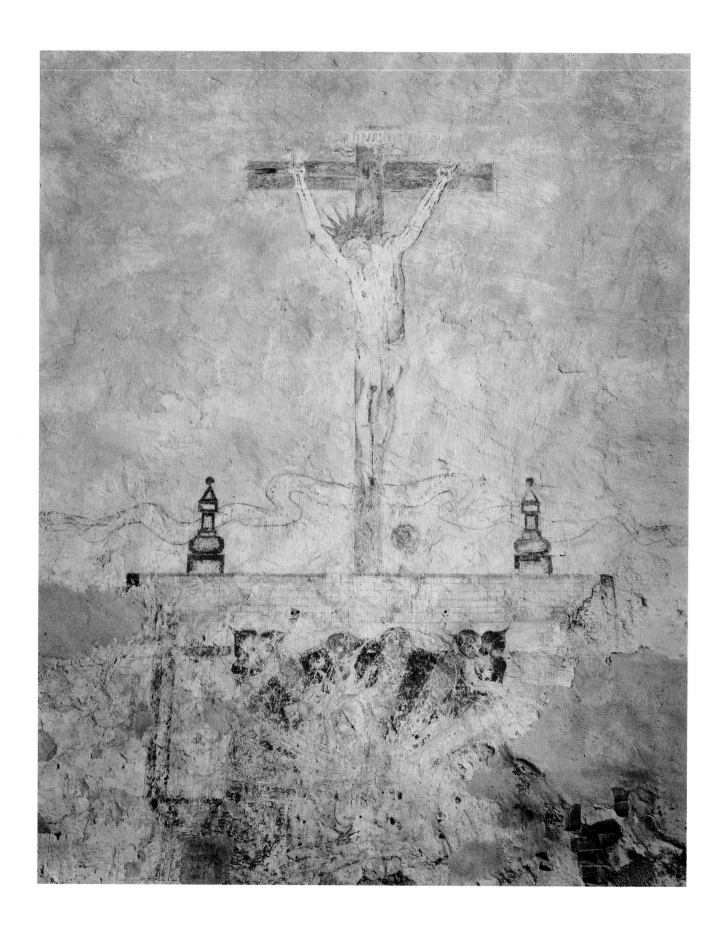

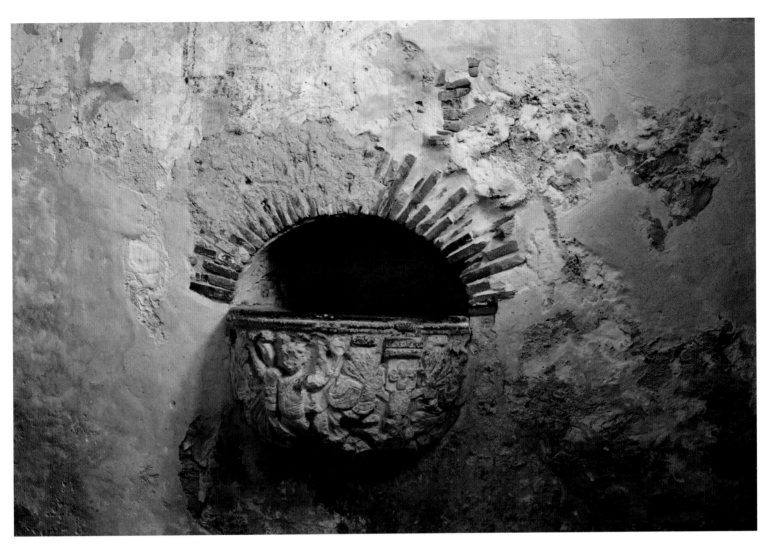

Major portions of an eighteenth-century fresco have been revealed above a baptismal font. The font's awkward placement, apparently made after this church was built, and the similarity of its stonework to that at Mission San Antonio de Valero, suggest that after that mission closed the font was moved to this still-functioning mission church.

Large fragments of brightly colored frescoes have been uncovered in the sacristy.

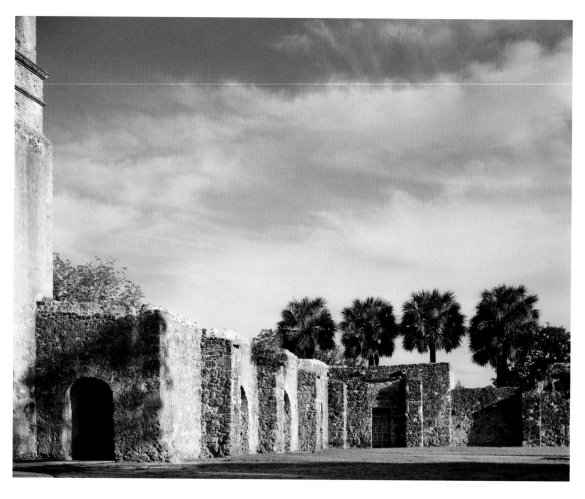

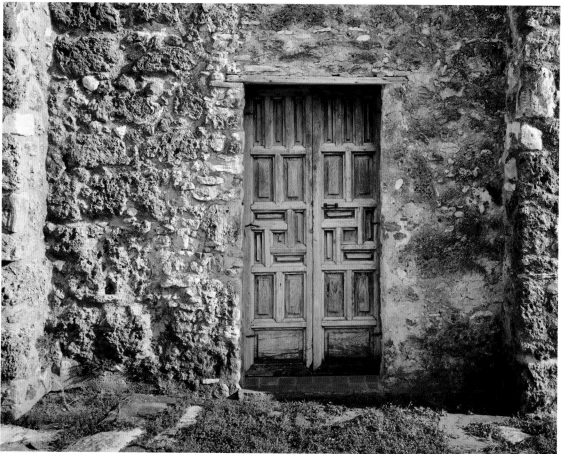

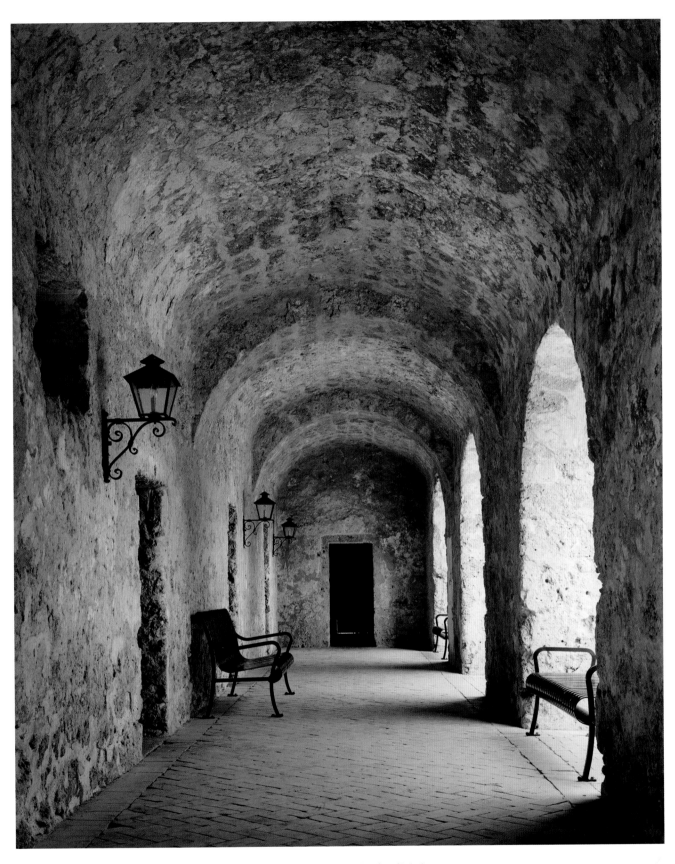

Major sections survive of Concepción's adjoining convento,
which housed workrooms and quarters opening off a cloister.

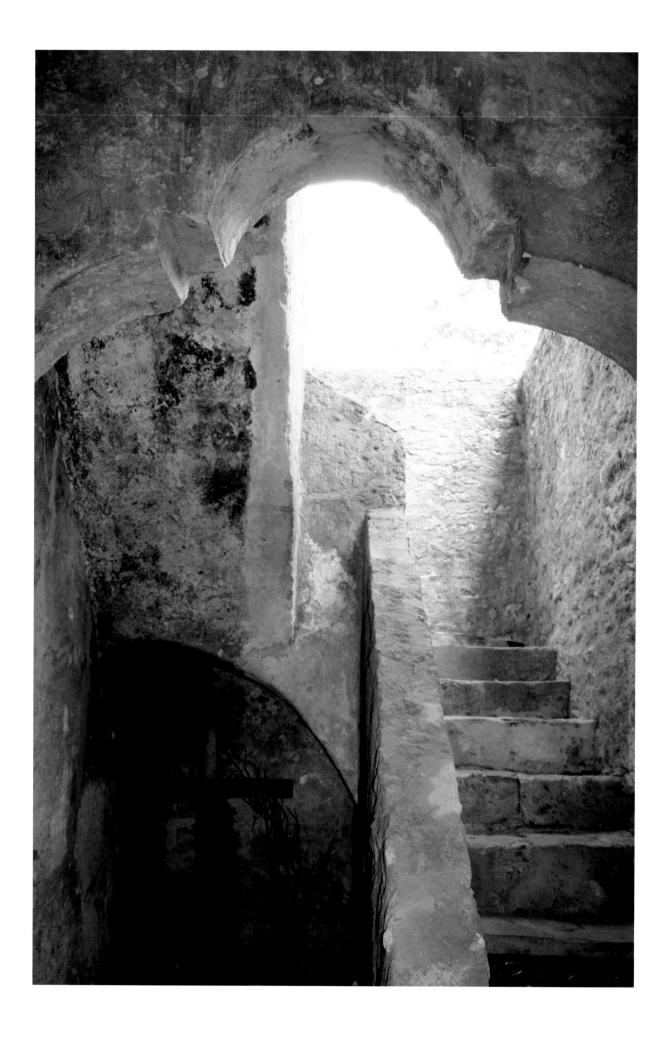

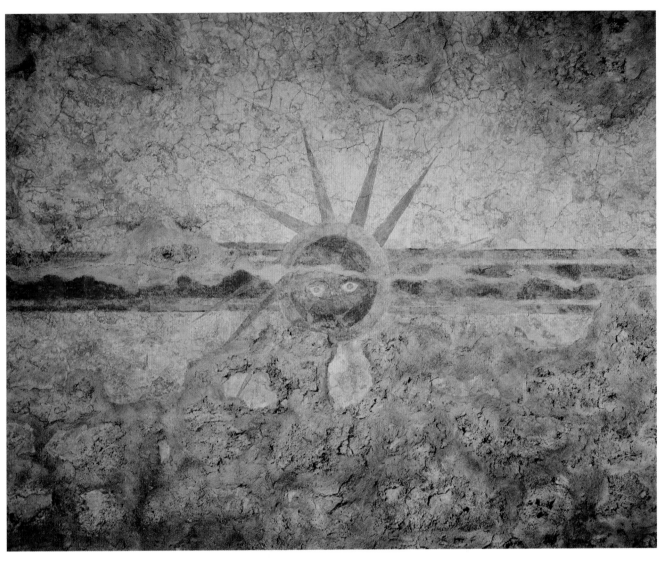

A distinctive feature fully revealed in a convento room
ceiling by a team of international art conservators in
1988 is this mestizo face, emanating sun-like rays
and thought to represent the face of God.

One unusual feature of Concepción's architecture is
the convento stairway framed by a graceful mixtilinear
arch, a popular Spanish Baroque era design featuring
an inner surface of broken convex and concave turns.

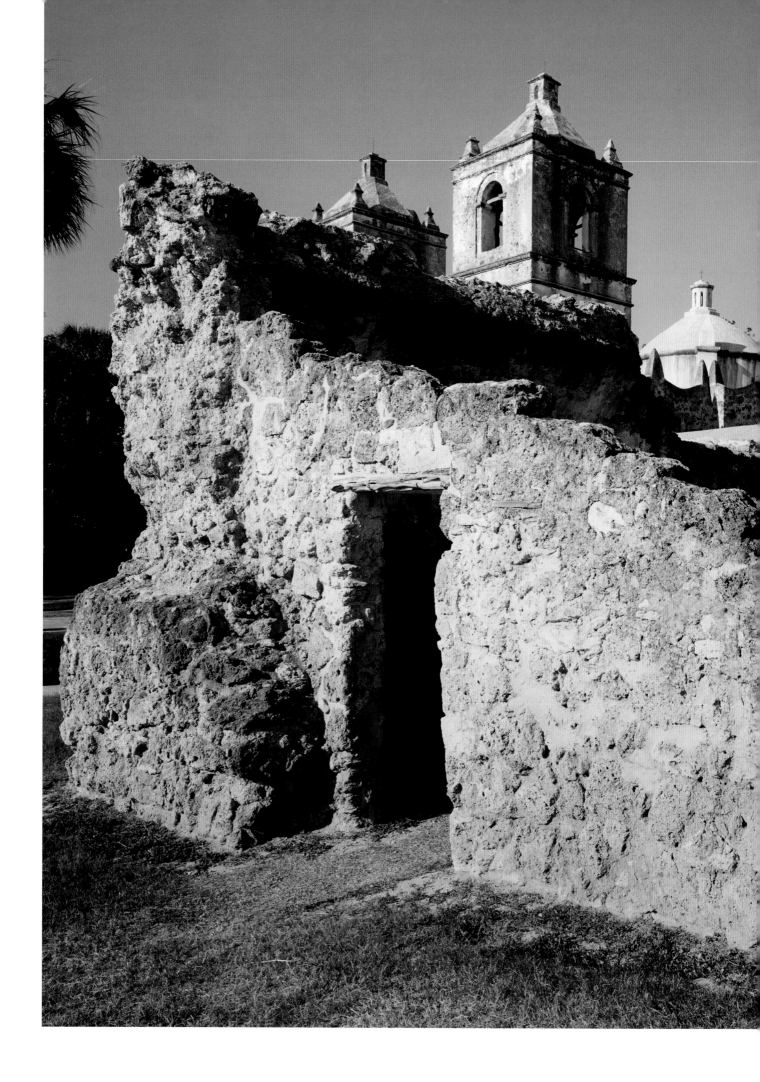

Rough latter-day additions to these original stone walls have been stripped away, leaving just the original stone.

3

MISSION SAN JOSÉ

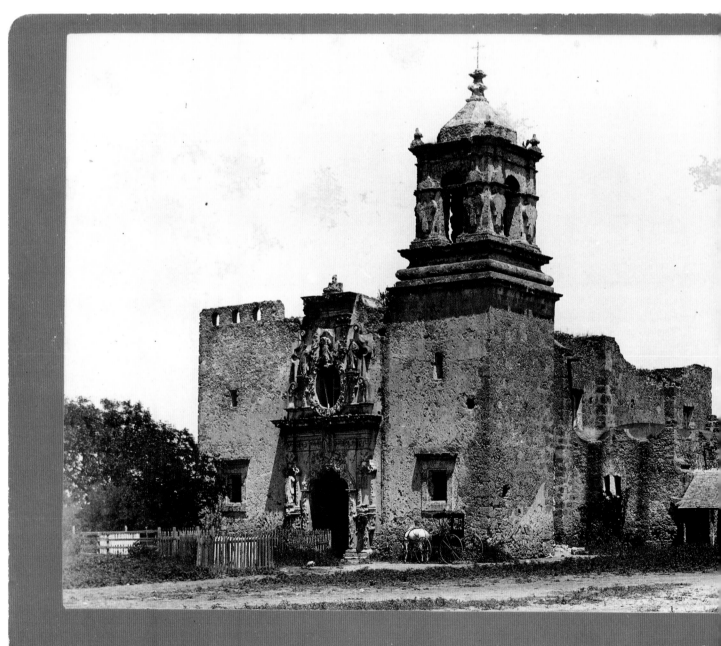

3

MISSION SAN JOSÉ

San José y San Miguel de Aguayo—the ending of its name honoring yet another Spanish nobleman—was the region's most successful mission. Founded in 1720 by the legendary Franciscan missionary Father Antonio Margil de Jesús, its Indian population approached 400, all living within the walls, farming outside and managing a ranch twenty-five miles away with more than 4,000 head of sheep and cattle. A stone granary could hold 4,000 bushels of corn. A church was begun in 1768 with some of the finest Spanish Baroque stone designs within the present-day United States.

A century later the mission was derelict. The stones of its perimeter walls were being scavenged for building projects. Part of one wall of the church collapsed in 1868. The roof, dome and north wall fell six years later. Souvenir hunters began taking down stone statues, breaking up the massive front doors and carrying off the pieces. Despite attempts to shore up the church facade, there seemed little hope for San José's survival. Small homes were built across the old mission plaza, soon criss-crossed by public roads.

Then in the mid 1920s the new San Antonio Conservation Society started buying the myriad of small privately held tracts in the former mission compound. Restoration of the complex began with the aid of Depression-era federal agencies, the Catholic Church and architect Harvey Smith. Mission San José was made a state park in 1941. Forty-two years later it became a key segment of the new San Antonio Missions National Historical Park.

HOTOGRAPHER.

A peaked roof extending from the south wall shields Mission San José's signature carved window in this 1880s view by San Antonio photographer Frank Hardesty, whose horse-drawn buggy may be tethered at the base of the tower.

39

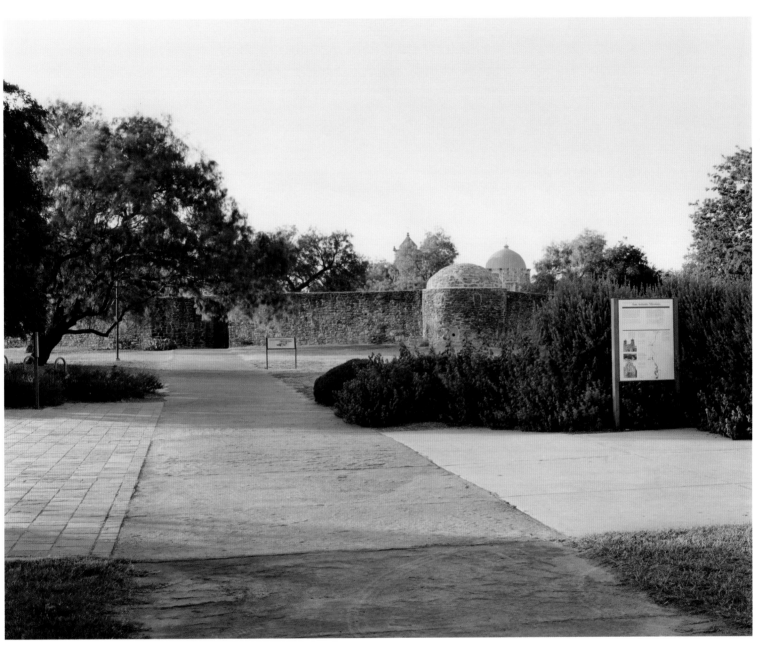

The Visitor Center for San Antonio Missions National Historical Park along with interpretive signs and beckoning pathways greet those arriving at Mission San José.

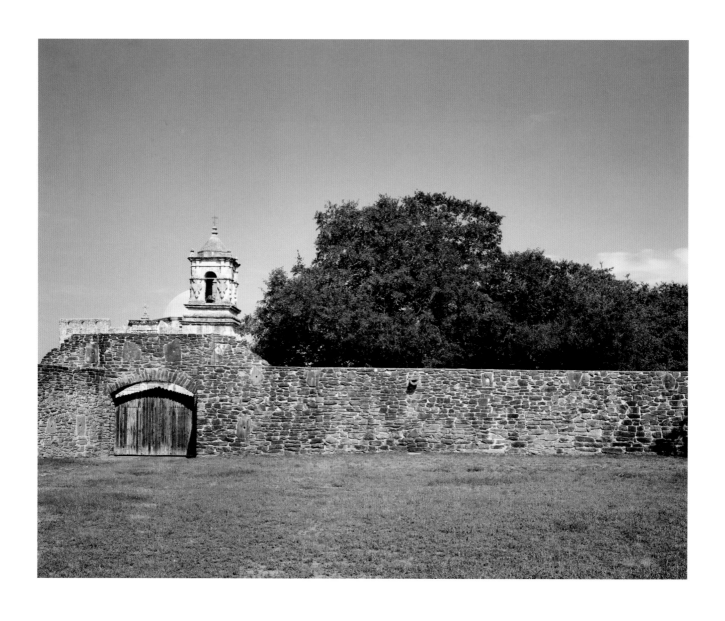

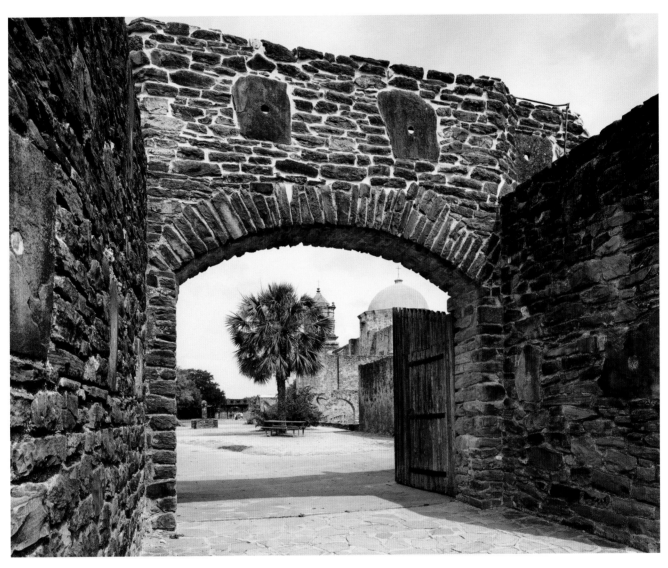

Perimeter walls rebuilt in the 1930s replicate those that originally protected mission Indian residents from hostile Apaches and Comanches.

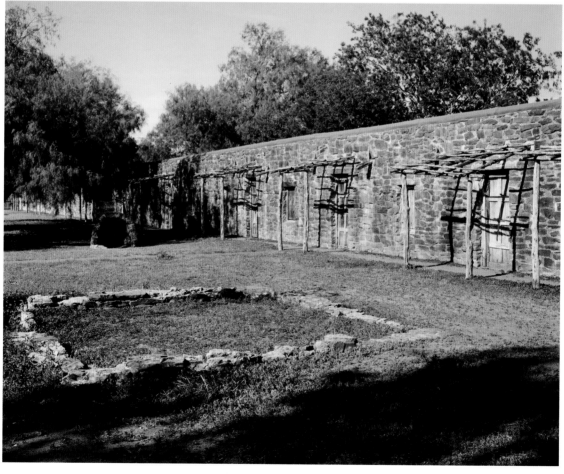

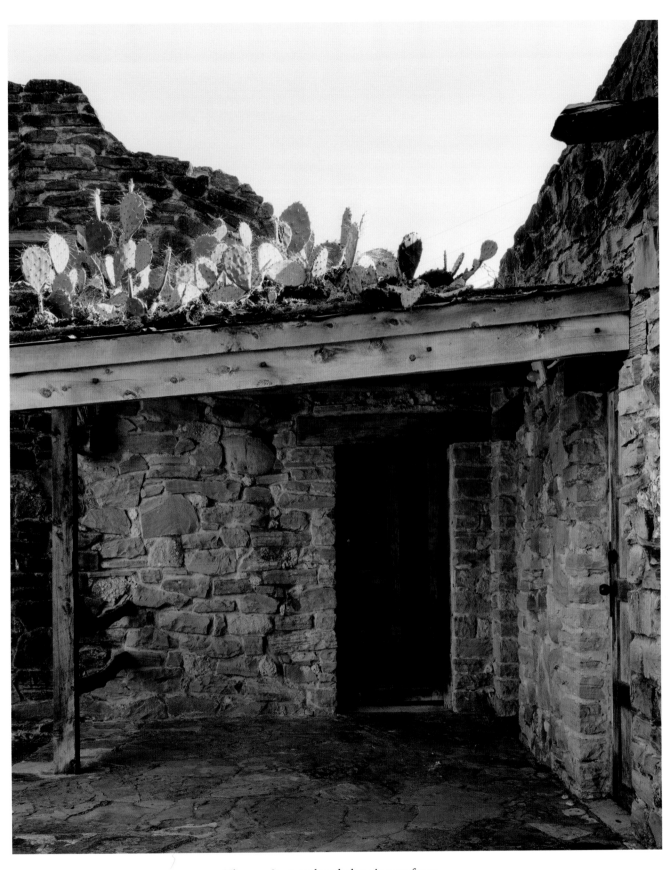

The spacious enclosed plaza is seen from
the small cemetery in front of the mission
church. The defensive walls doubled as
exterior walls for mission Indians' quarters.

A primitive sink is a feature in one perimeter room that may
have housed Spanish soldiers garrisoned at the mission.

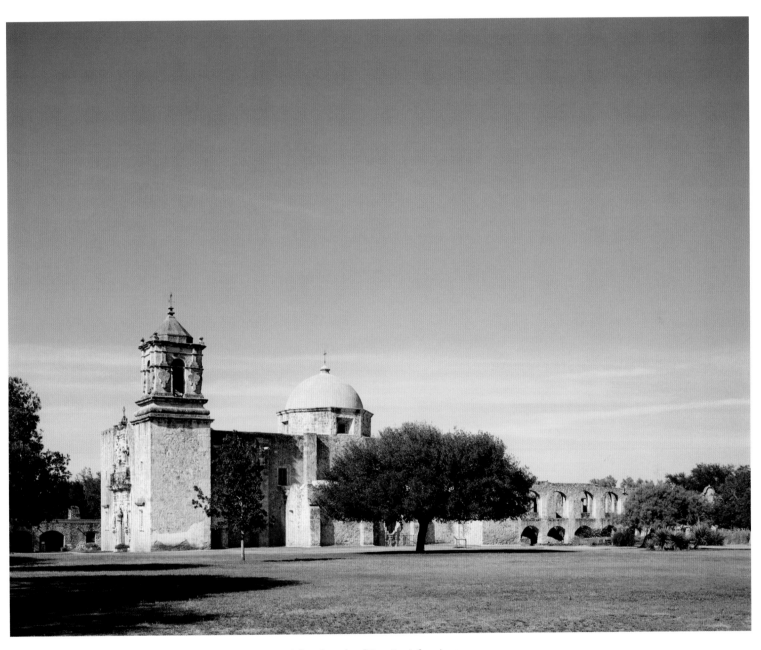

The church of San José dominates
the north end of the mission plaza.

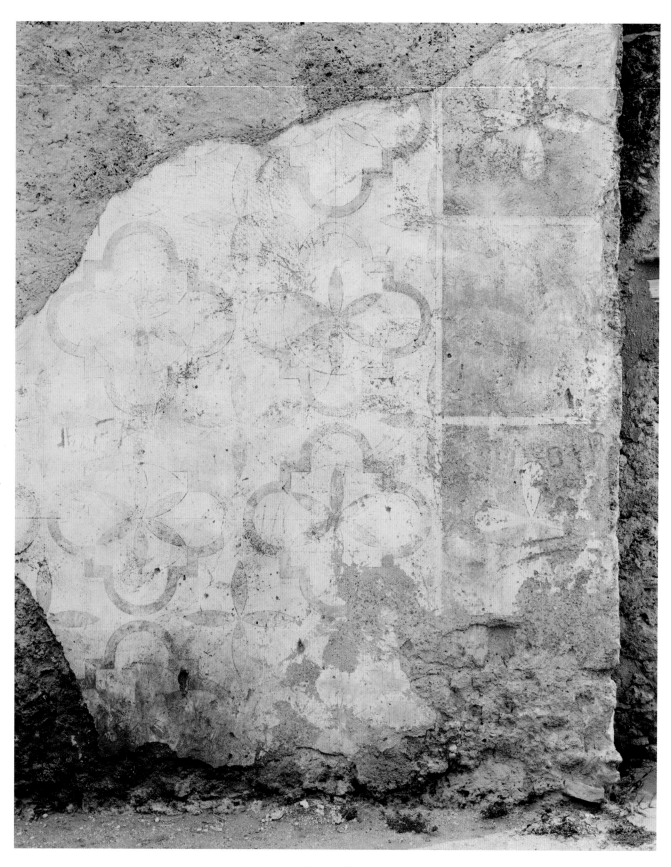

Spanish Baroque carving on the facade of San José's mission church is among the finest in the United States. Above the oval window is a sculpture of St. Joseph, the mission's patron saint. To its left is St. Dominic, to its right St. Francis of Assisi, founder of the Franciscan order. On either side of the doorway are the Virgin Mary's parents, St. Joachim and St. Anne. Above is the Virgin of Guadalupe, now the patron saint of Mexico. At the base of the tower is a now-faded restoration of the facade's original brightly painted geometric and floral designs.

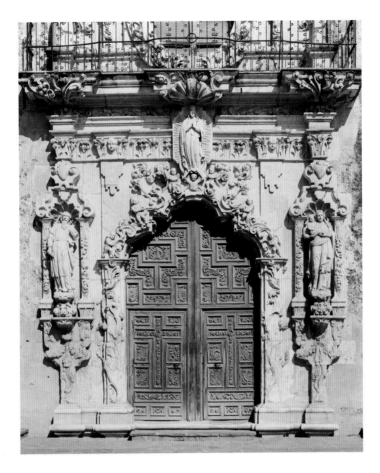

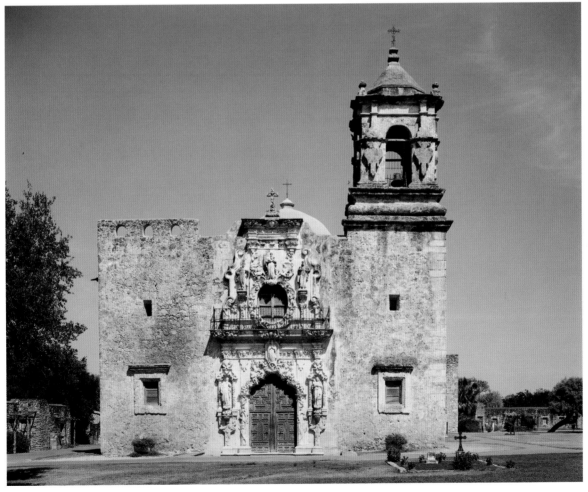

49

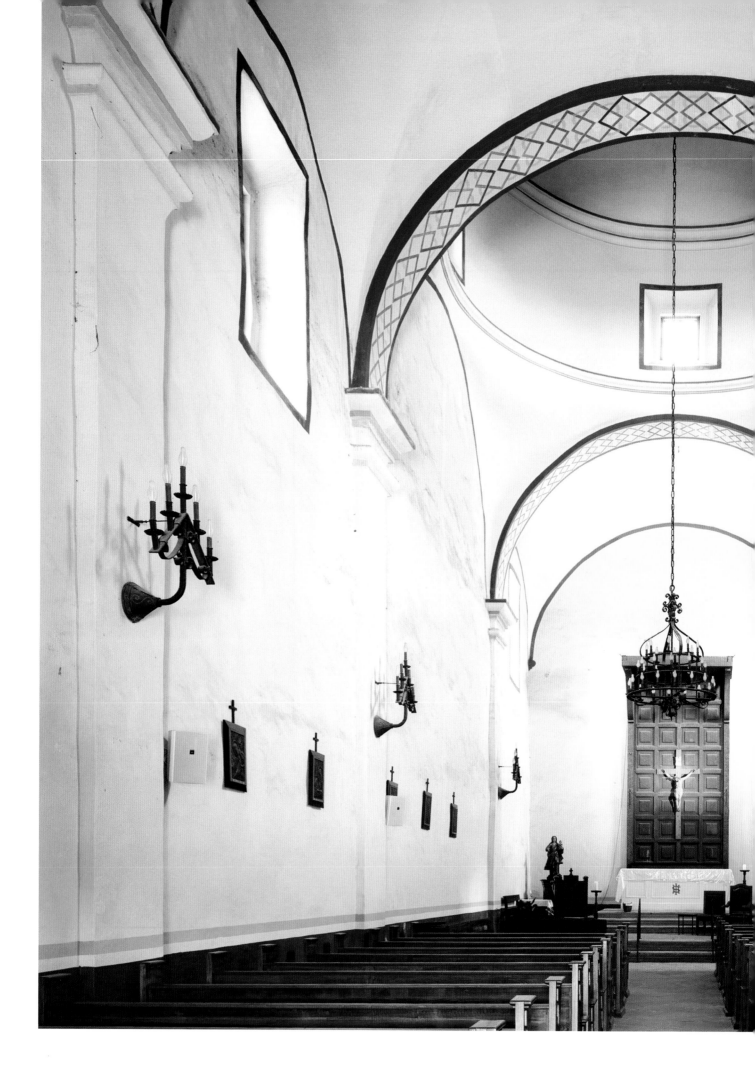

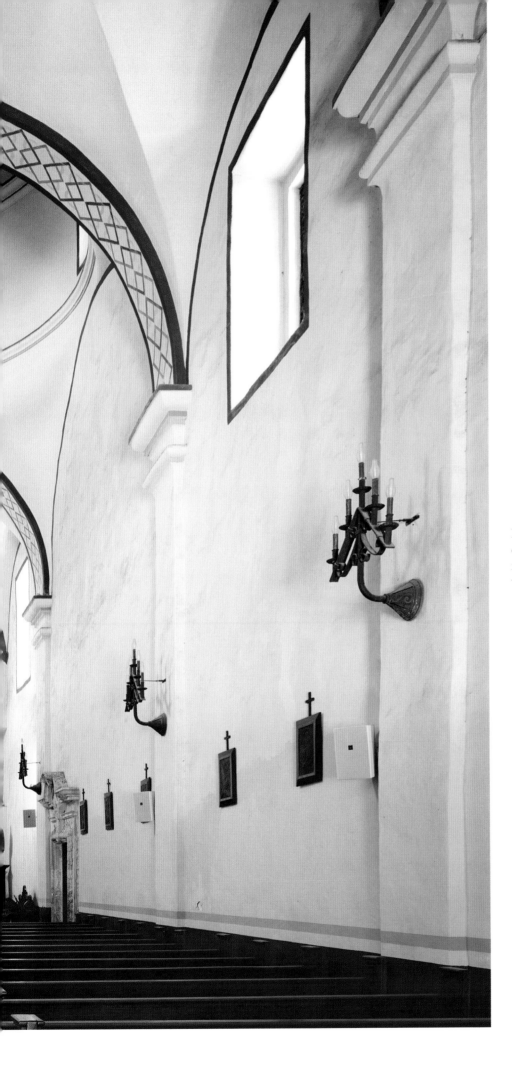

Restoration of the soaring interior of San José's church—including rebuilding two walls, the roof and the dome—was completed in 1937.

Tourists help fill the pews at San
José's mariachi mass each Sunday.

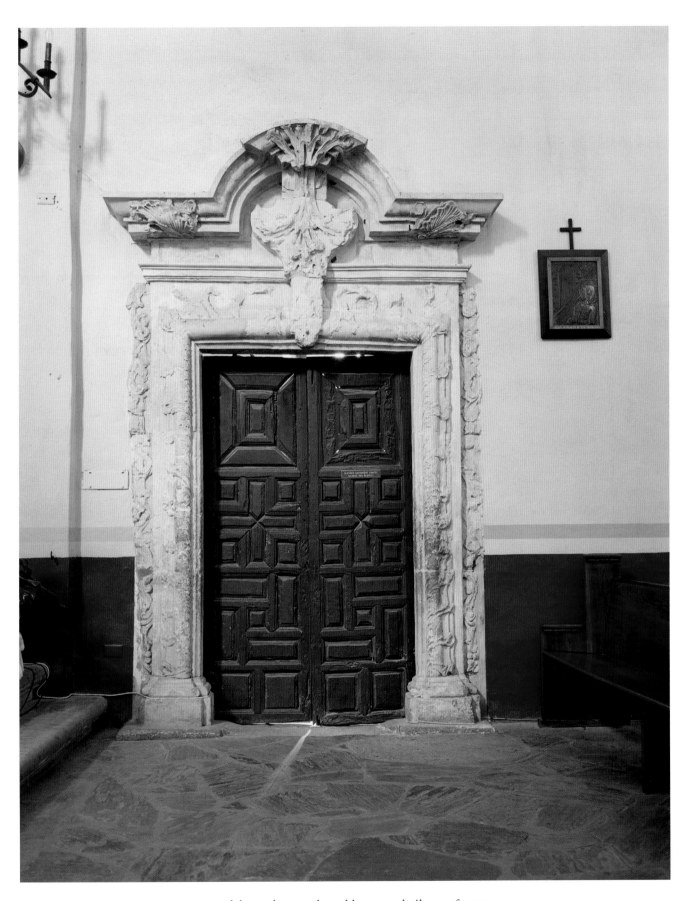

An elaborately carved entablature and pilasters frame
the doorway from the church into the sacristy.

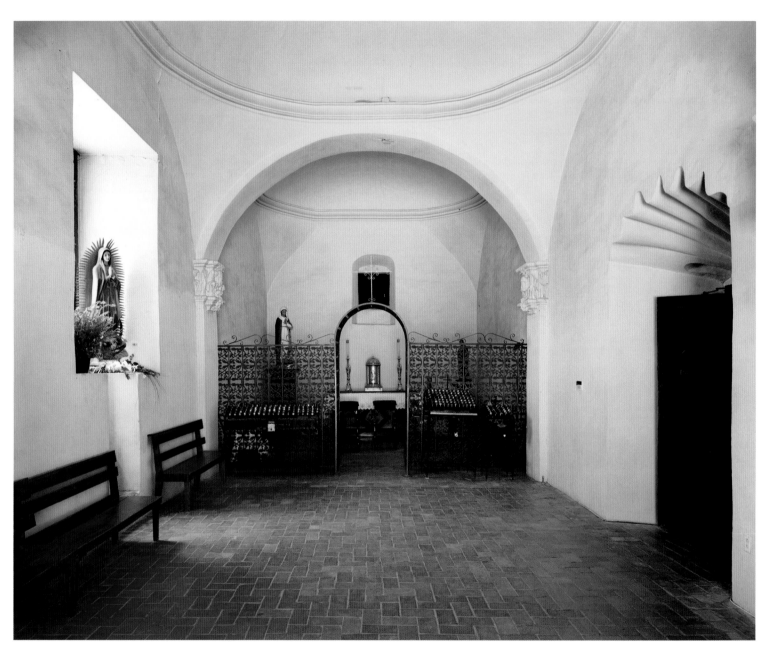

The three domes that form the ceiling of San José's sacristy, completed in 1777, have remained intact. Across from the shell-shaped arched doorway from the sanctuary is the opening for the elaborately carved sacristy window. Reminders of modern-day use are candles by the ornamental screen and a statue of the Virgin Mary beside the sacristy altar.

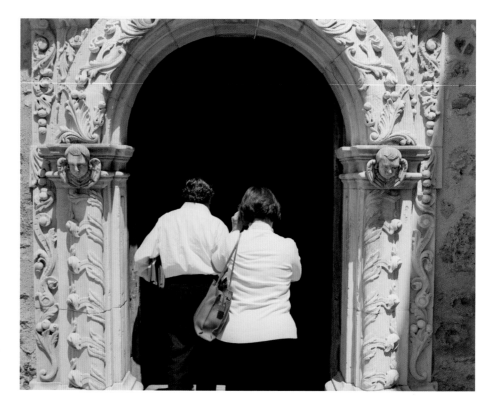

A decorative doorway arch frames the sculpted exterior entrance to the sacristy.

Opening into the sacristy at the southeastern corner of the church is the iconic sculpted window now believed originally to have honored St. Rose of Lima, Peru, the first native-born Catholic saint in the Americas.

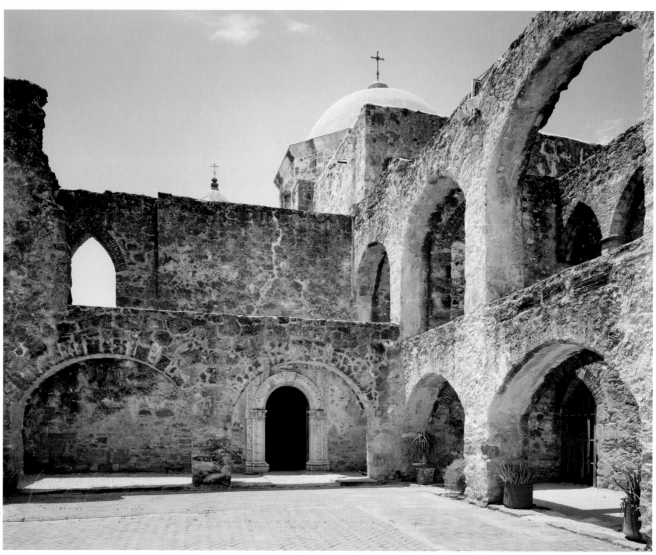

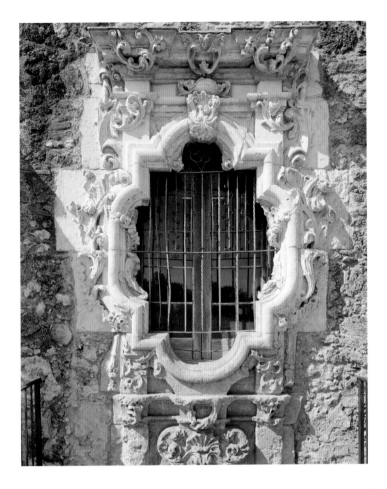

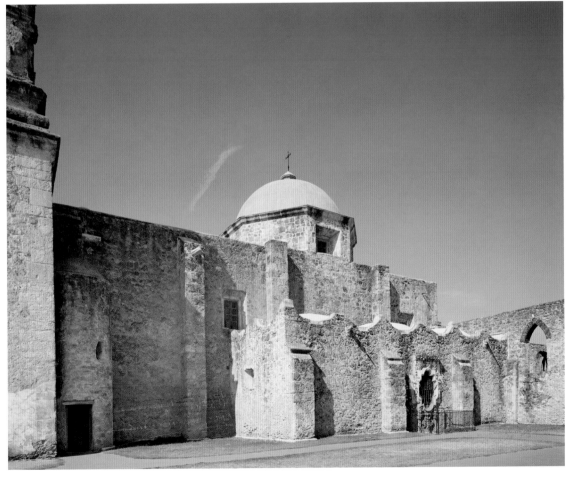

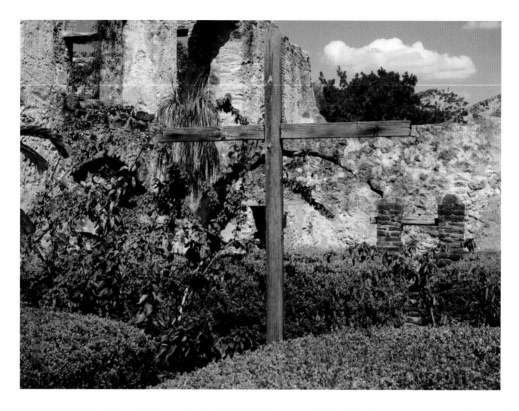

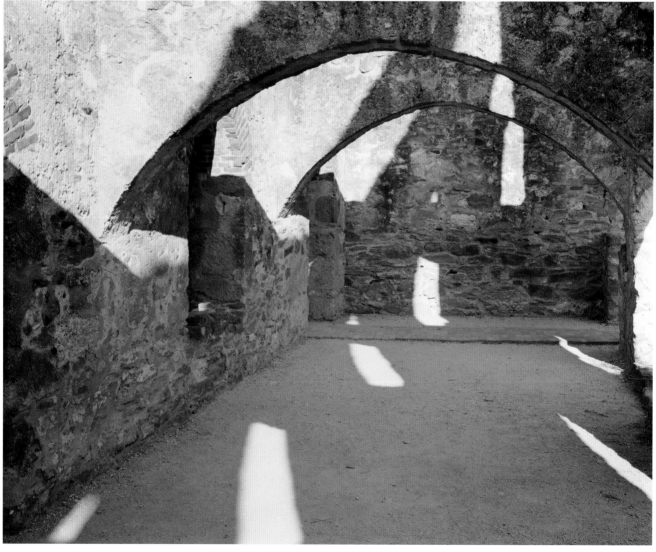

In the courtyard garden outside the sacristy, a Romanesque arched wall of the original mission convento is still attached to the eastern wall of the church. Gothic arches were added in an uncompleted 1860s renovation project for a monastery.

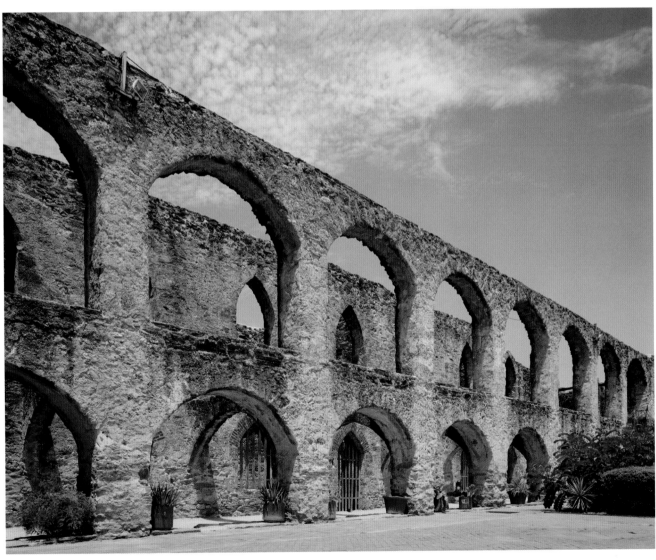

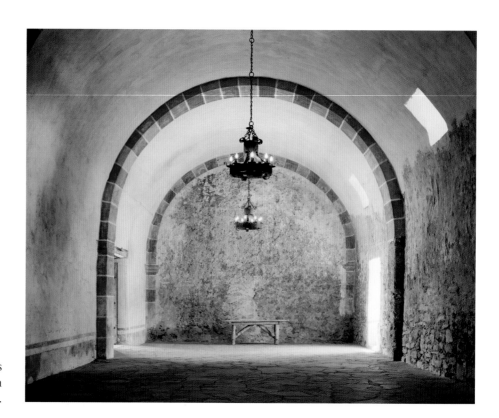

Buttresses support the walls and vaulted roof of the mission granary, completed by 1758.

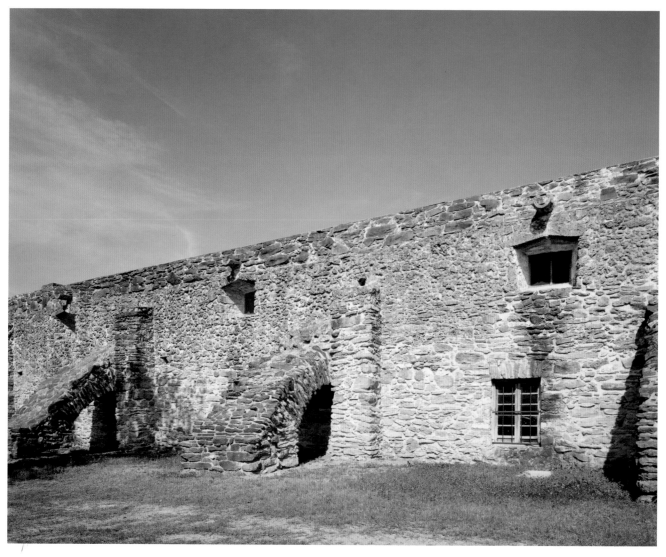

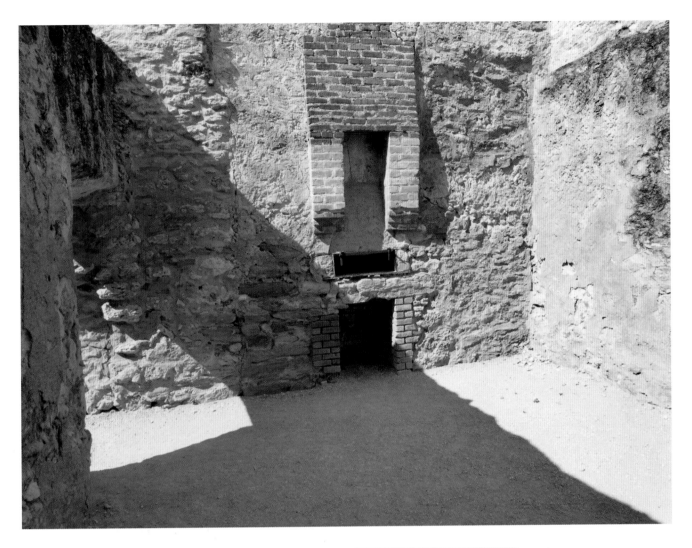

above
An oven thought intended for baking bread was built in a wall of the old convento area by Benedictine priests who lived at San José from 1859 to 1868.

left
Imbedded in the granary's west wall, a tablet—itself now historic—credits those responsible for the granary's reconstruction in 1933.

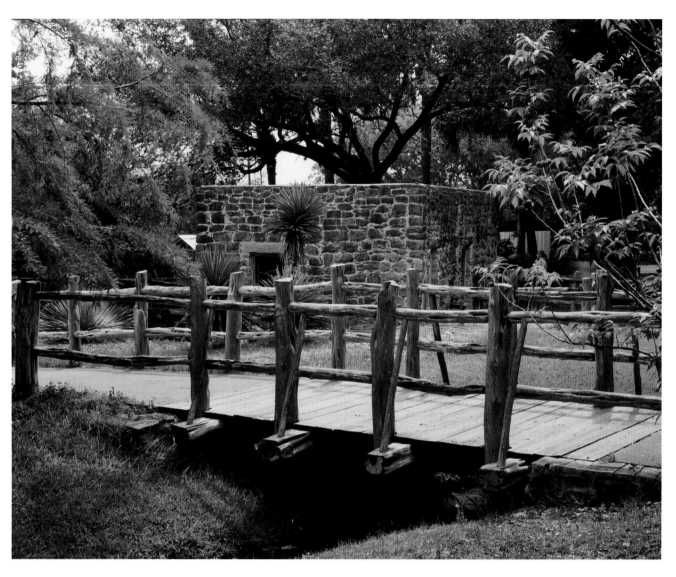

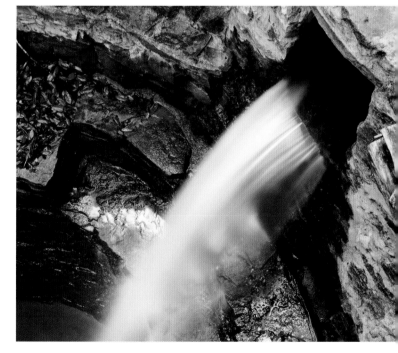

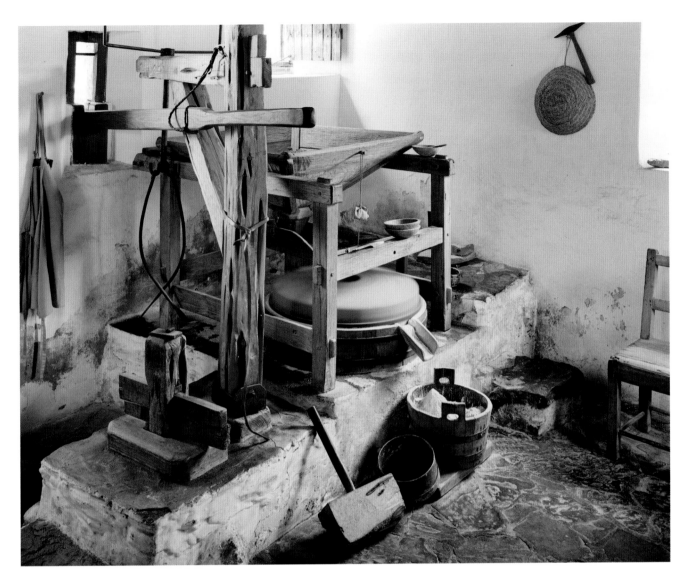

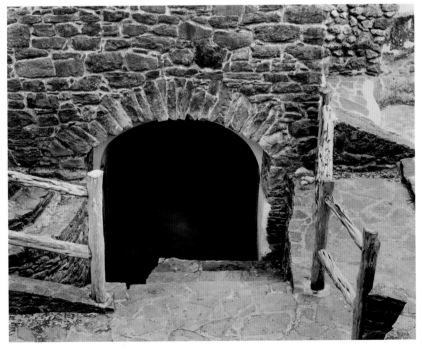

San José's gristmill, among the first in Texas, was built just outside the mission walls in the 1790s and reconstructed in the 1930s. A flow of water was restored in 2001. Water is diverted from a section of the original mission acequia into a narrow stone-lined channel. It fills a receiving basin, then falls through a chute to turn the horizontal millwheel on the lower level. The wheel turns a shaft connected above to a millstone, which grinds the wheat and dispenses the flour into a bucket.

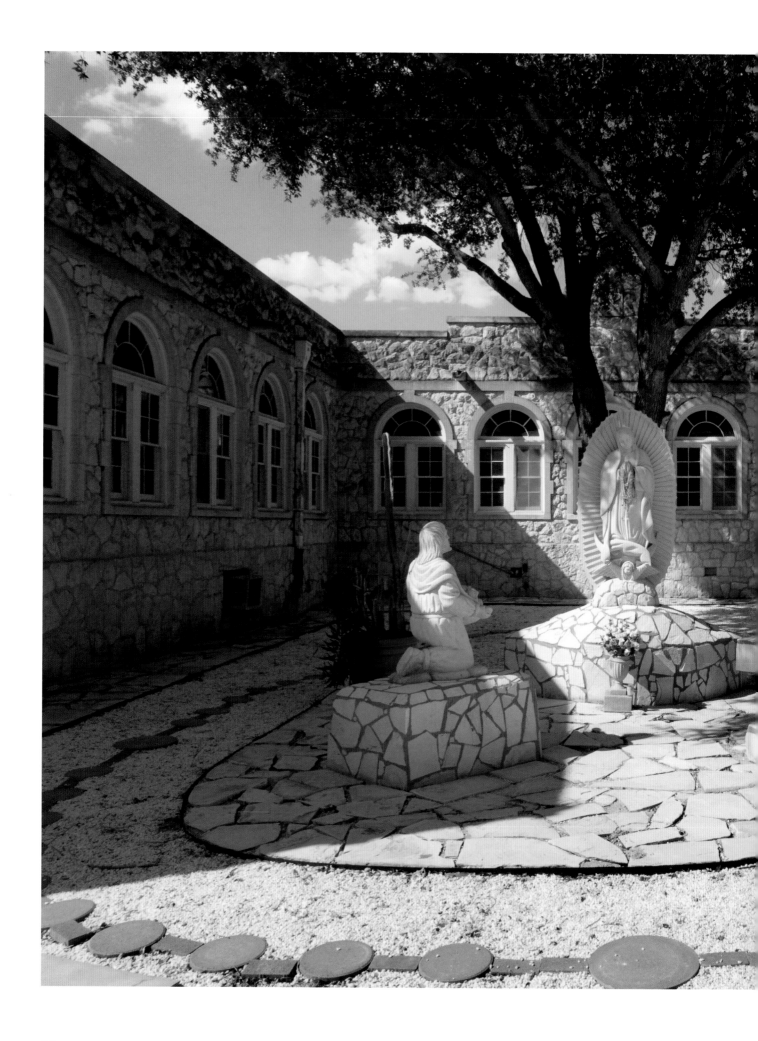

Outside the east gate of the mission is a friary built to house Franciscan priests in 1931, when the order returned to San José after an absence of more than a century. The courtyard sculpture features a priest praying to the Virgin of Guadalupe.

4

MISSION SAN JUAN

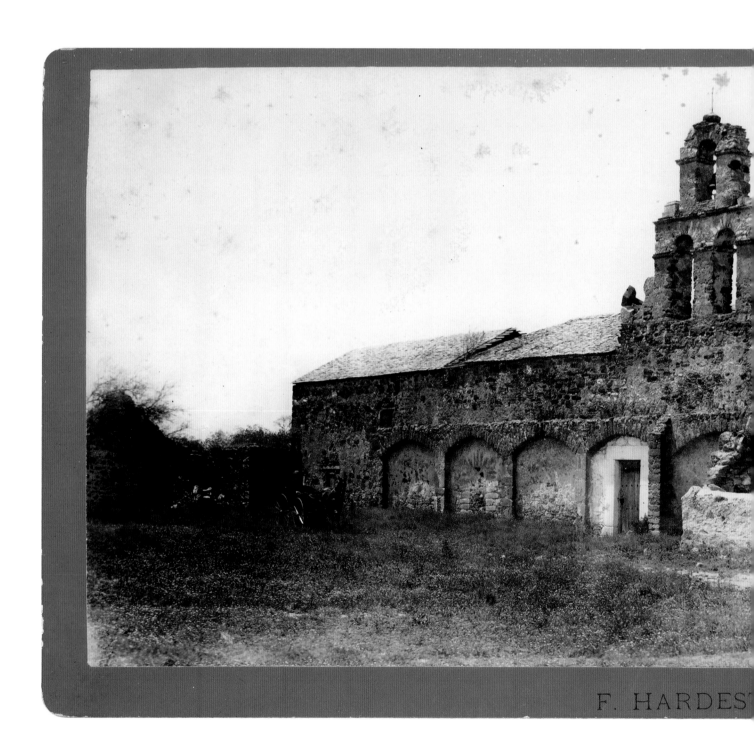

4
MISSION SAN JUAN

Mission San Juan Capistrano, its origins in East Texas, was moved to San Antonio in 1731. It was named in honor of newly canonized St. John of Capistrano, the Italian-born Franciscan priest and military leader credited with a critical victory over the Turks at Belgrade in 1456. By the mid-1750s a straw-roofed chapel of brush and mud had been replaced with a wood-roofed stone chapel, its five recessed arches on one side facing the plaza and topped by an espadaña, a two-tiered open belfry with three bells. Work soon began across the plaza on a permanent church, to have a sacristy with octagonal walls.

Due to the outlying mission's dwindling Indian population, however, there were too few workers to complete the church, leaving the chapel to symbolize the mission for future generations. In the mid-1870s the chapel was re-roofed for services by a French immigrant lay priest, Francis Bouchu. Permanent repairs were completed by the Catholic Church in 1909. In the 1960s public roads through the old plaza were closed and nearby buildings were reconstructed. Artifacts excavated at the time are displayed in a small visitor center.

Mission San Juan's chapel appears in the 1880s with a wooden roof added a decade before by a French immigrant lay priest who held services inside.

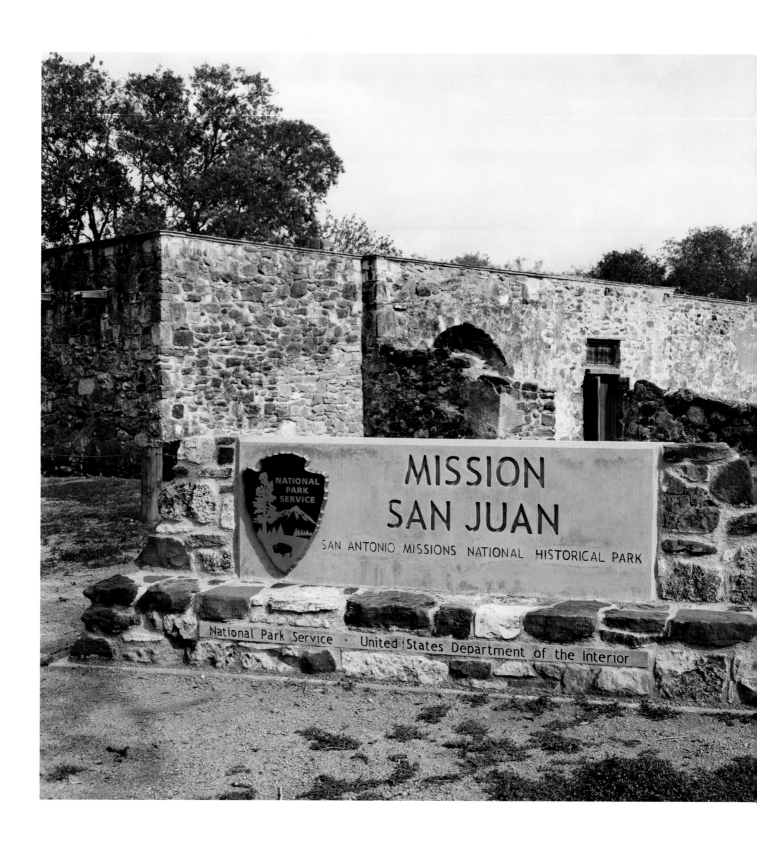

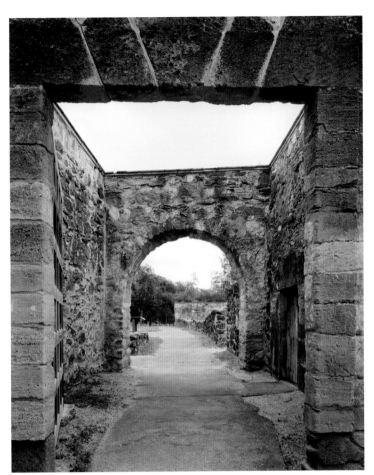

Mission San Juan was originally entered through this gated entry area to the convento compound at the southwest corner of the mission plaza.

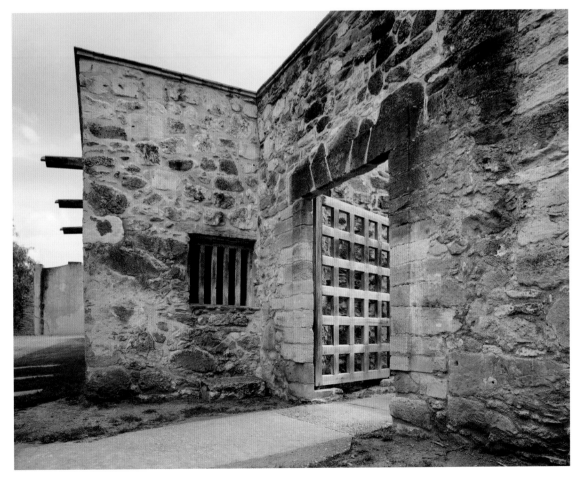

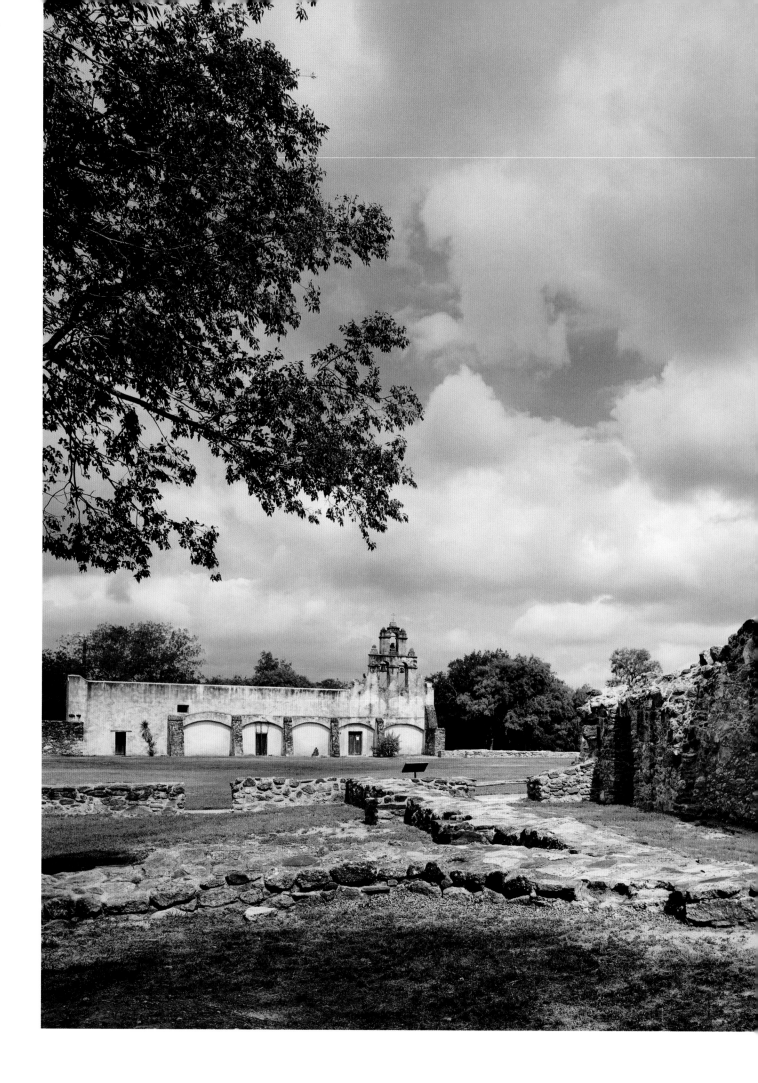

Foundations of an octagonal sacristy and unfinished walls for the adjoining sanctuary are all that remain of the permanent church planned for San Juan. Worship in the closing days of the mission continued in the chapel across the plaza.

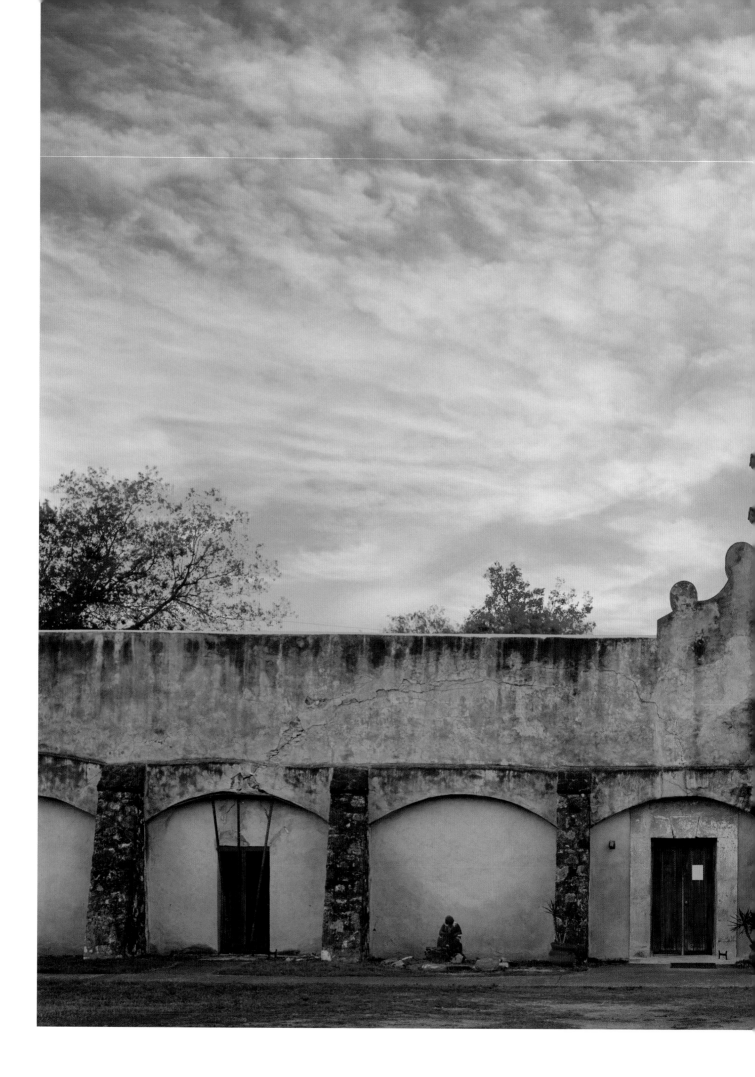

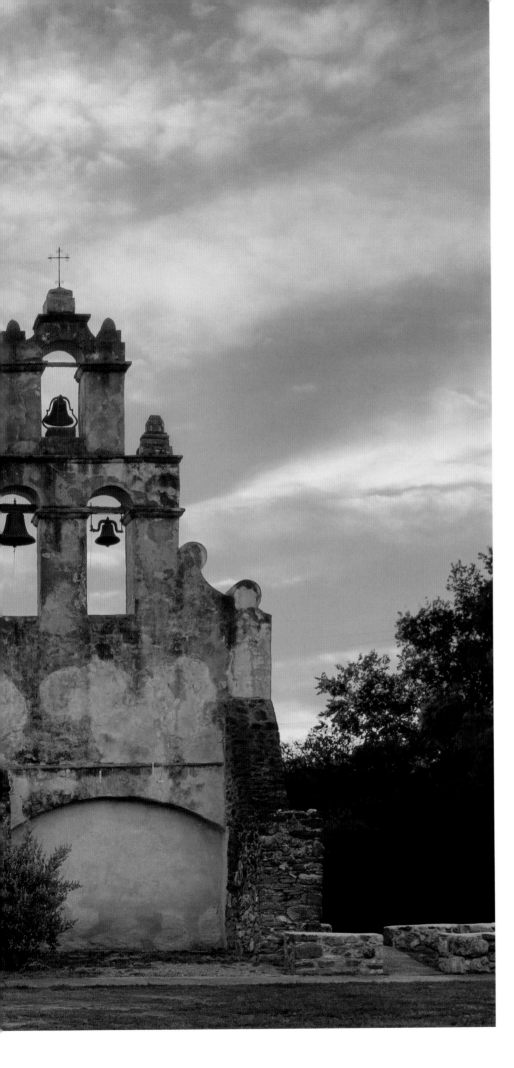

Bells in the San Juan chapel's two-tiered tower are outlined at sunset.

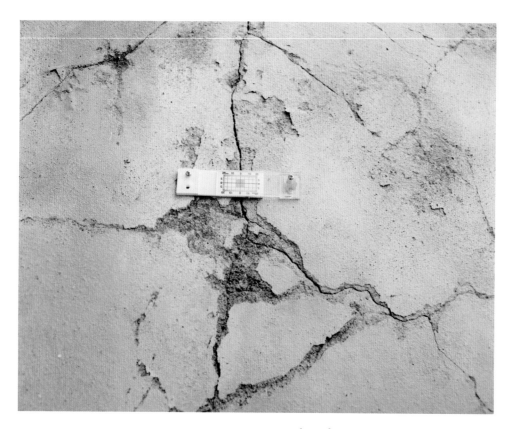

The infirmities of age require constant attention to San Antonio's Spanish missions. A crack in the south wall of San Juan's 1750s chapel is shown buttressed and monitored by a measuring device until repairs can begin.

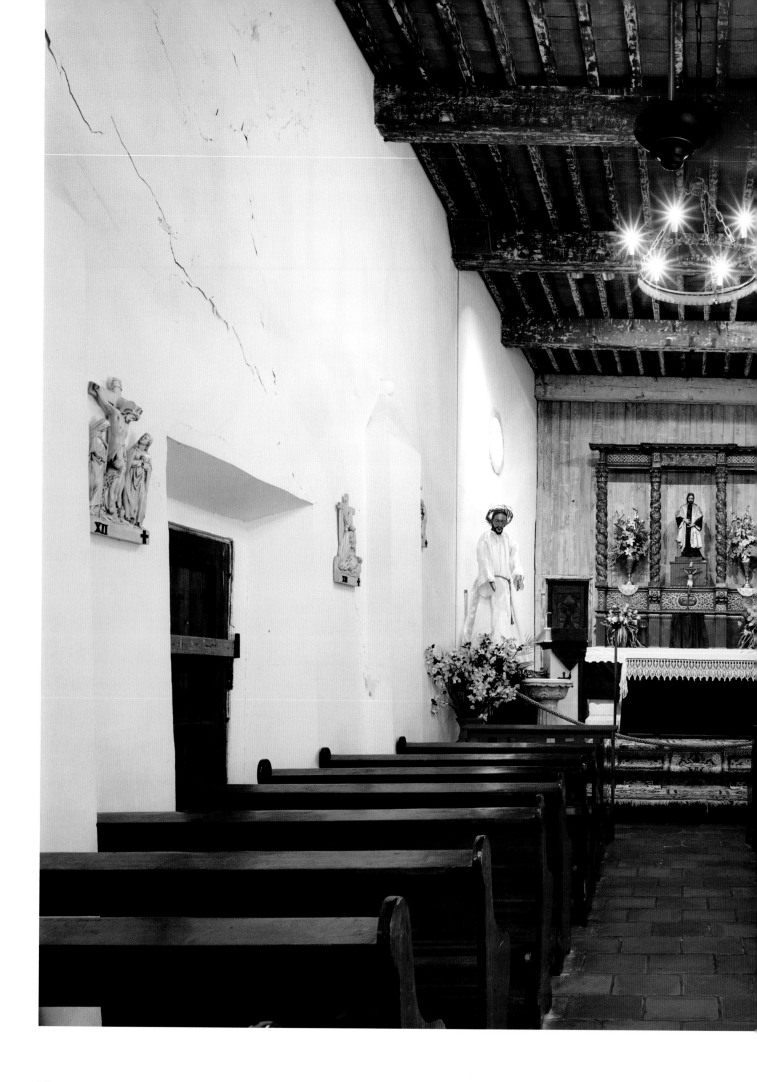

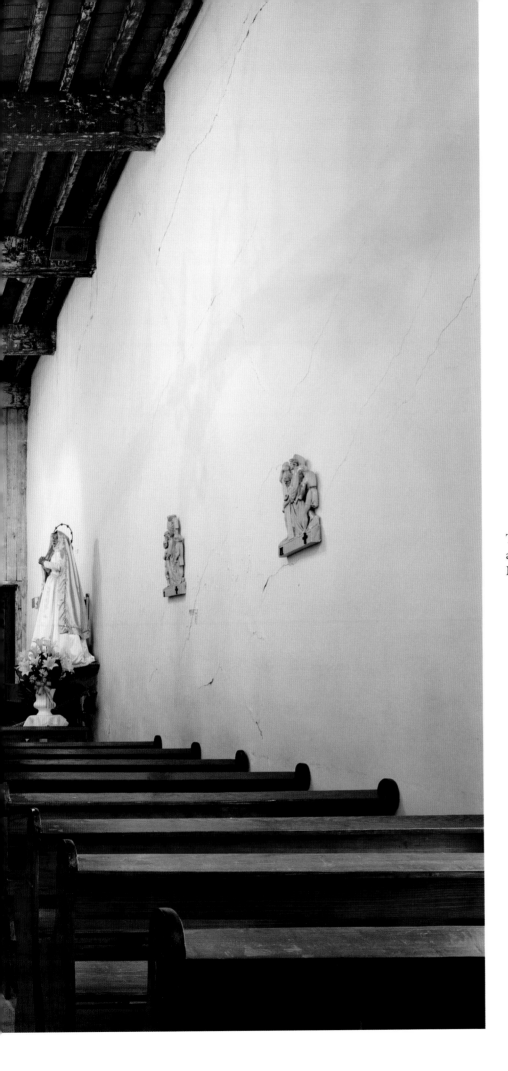

Two narrow rows of pews accommodate worshippers inside Mission San Juan's chapel.

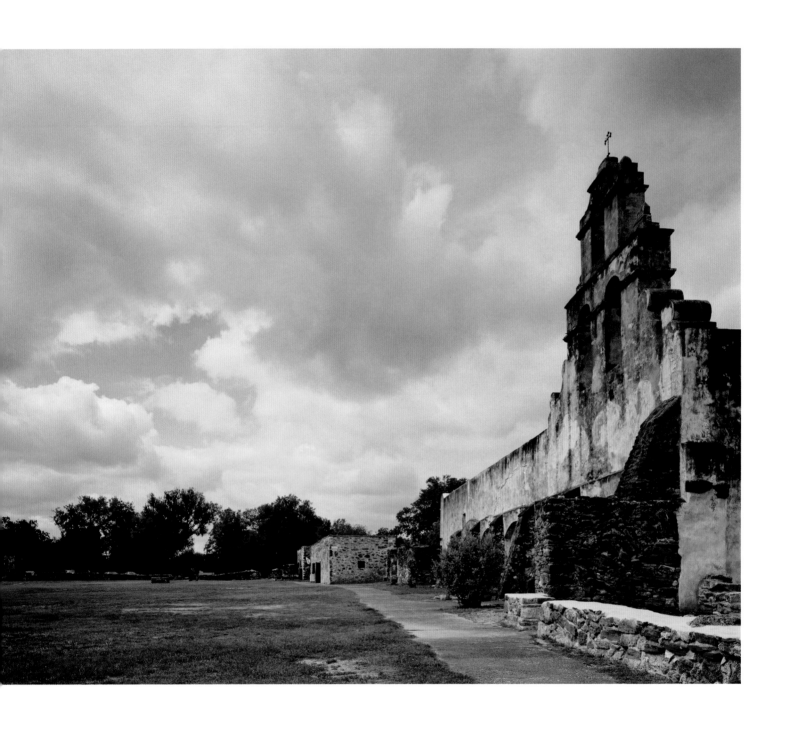

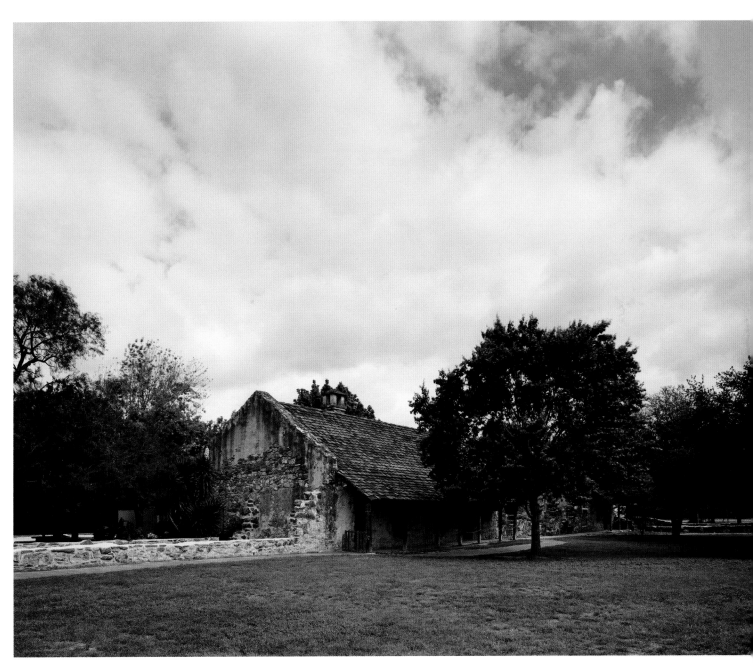

Along the north side of the plaza, the gate house
and convento remains are to the west of the chapel,
homes reconstructed for parish priests to the east.

5

MISSION ESPADA

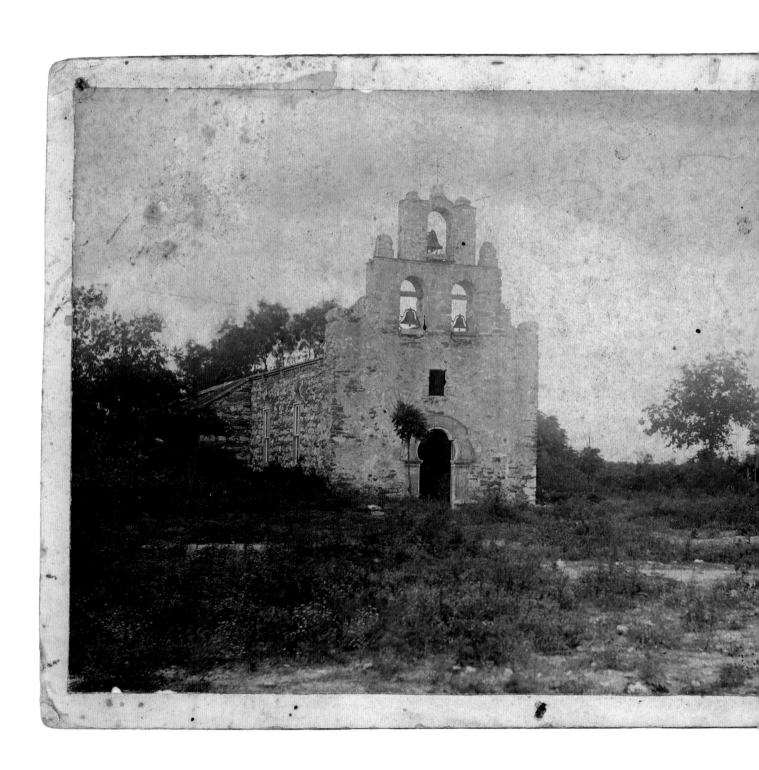

5

MISSION ESPADA

Mission San Francisco de la Espada had its turbulent origins as the first mission in Spanish Texas, established in 1690 near present-day Nacogdoches. Origin of the name Espada is now a mystery. The chapel was completed in the mid-1750s to serve until a larger, permanent church nearby, begun in 1762, was completed. Soon after being finished, however, the new church was found to be structurally unsound and was torn down. Use of the old chapel resumed.

Espada was the furthest mission from the main settlement at San Antonio, some eight miles away. Both before and after the mission's closing the neighborhood suffered raids by Comanches, and Mexican soldiers sent to defend residents added a round bastion to the fortified mission walls. The facade was practically all that remained of the mission chapel by 1885, when Father Francis Bouchu moved from San Juan to rebuild Espada's chapel and adjoining buildings.

Notable survivals from mission times are the nearby dam and aqueduct, part of an acequia system begun in 1731 to irrigate mission fields that has remained in use through succeeding generations. Thirty miles south, near Floresville, the National Park Service preserves a central 100 acres of Espada's mission ranch—Rancho de las Cabras, or Ranch of the Goats—with outlines of the foundations of the ranch's chapel, quarters and corral.

By the 1890s, the crumbling facade of Mission Espada's chapel was saved and incorporated into reconstructed side and rear walls. The house on the site of part of the mission plaza's perimeter wall, at right center, once housed a community school.

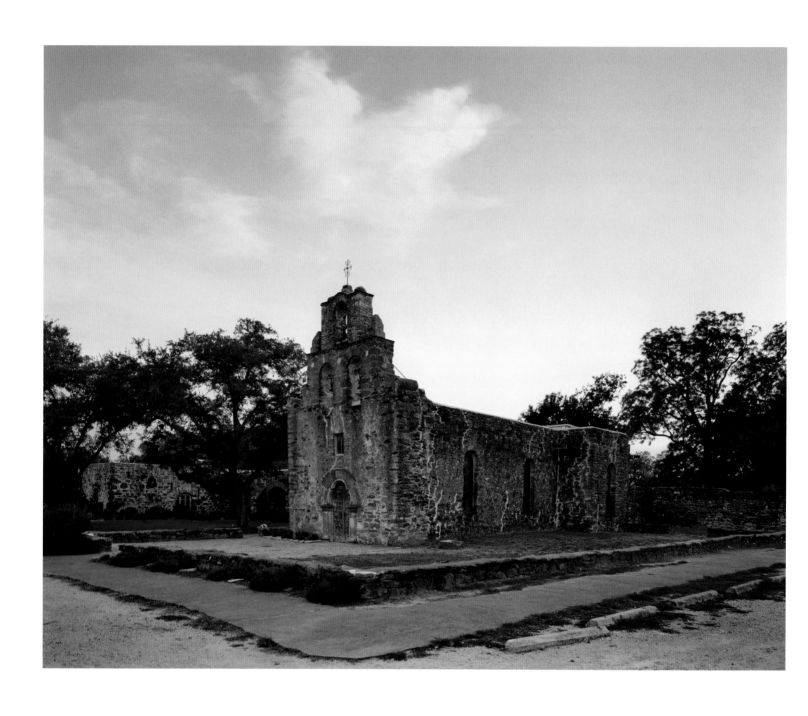

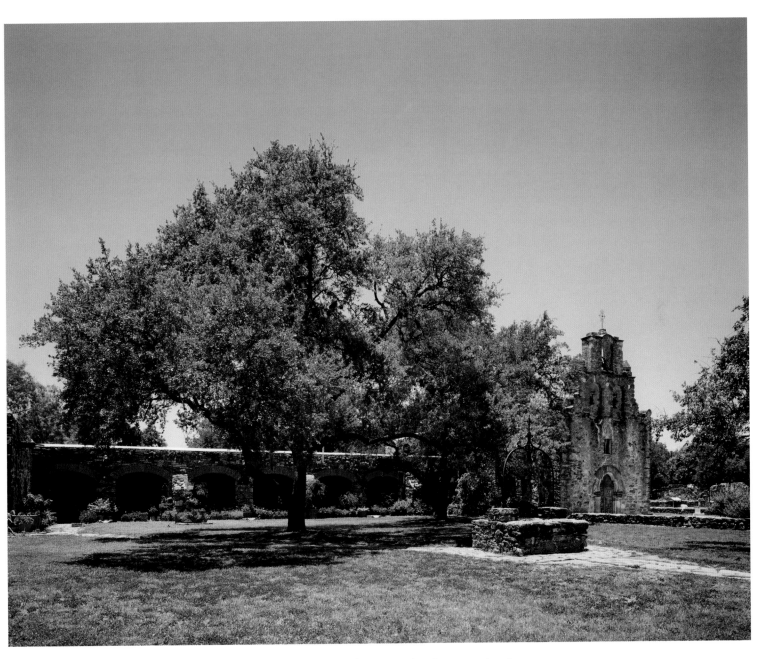

Reconstructed cloisters front on priests' quarters in what
was originally a two-story convento. The rebuilt mission
building at far left once served as a community store.

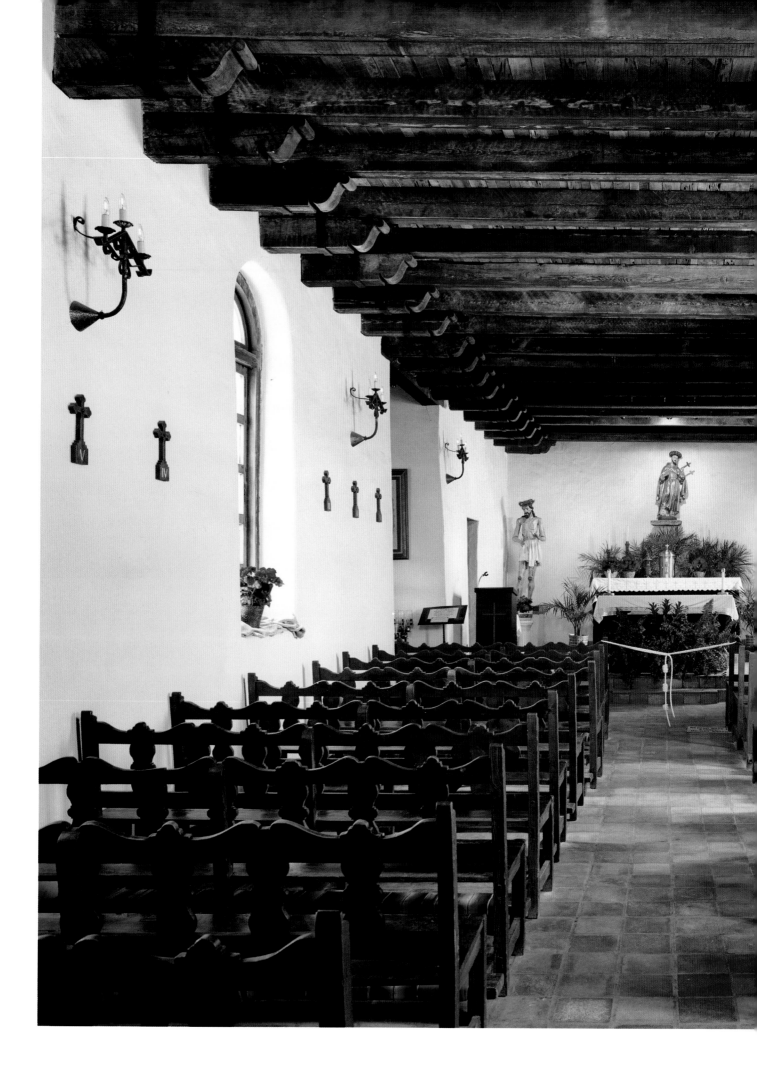

Mission Espada's intimate chapel has a ceiling of cypress beams, part of a restoration project that followed a small fire in 1998 and included reconfiguring the low attic for air conditioning.

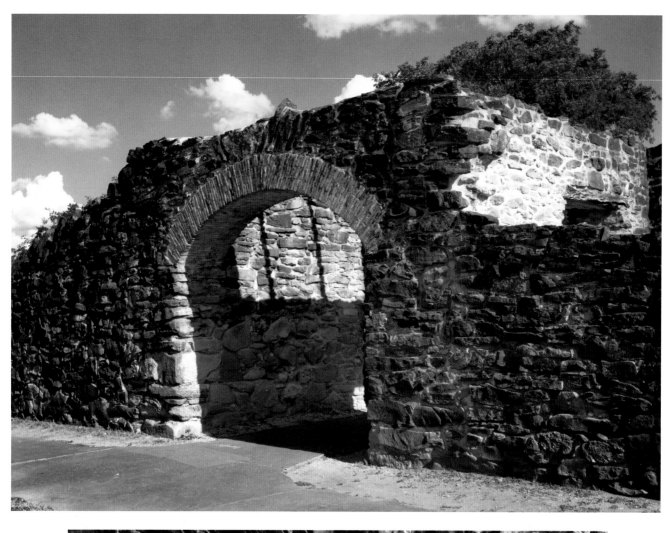

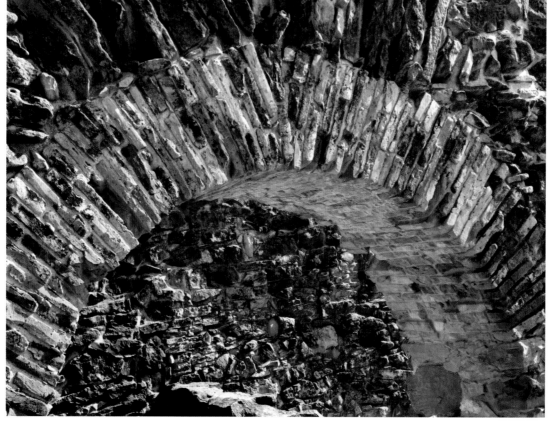

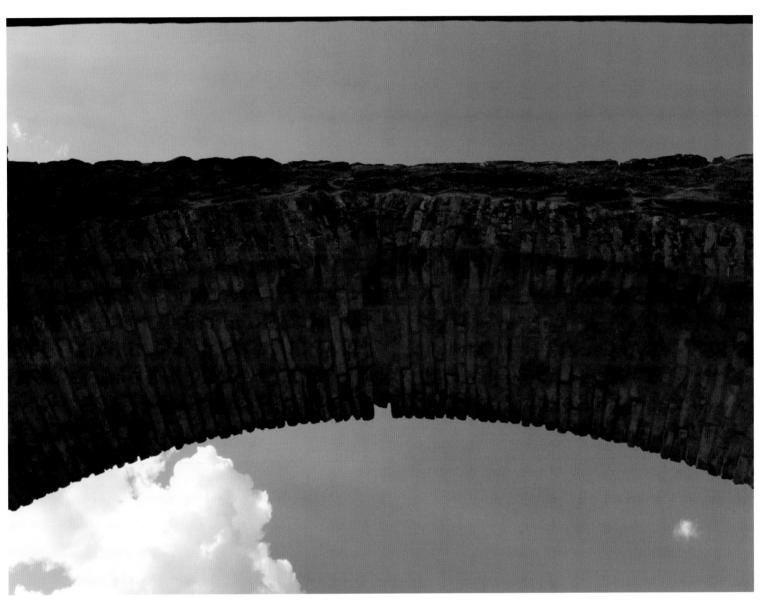

Proximity to clay soil useful for firing bricks led to the opening of a mission brickyard. It provided more brickwork for Espada than is found at San Antonio's other missions.

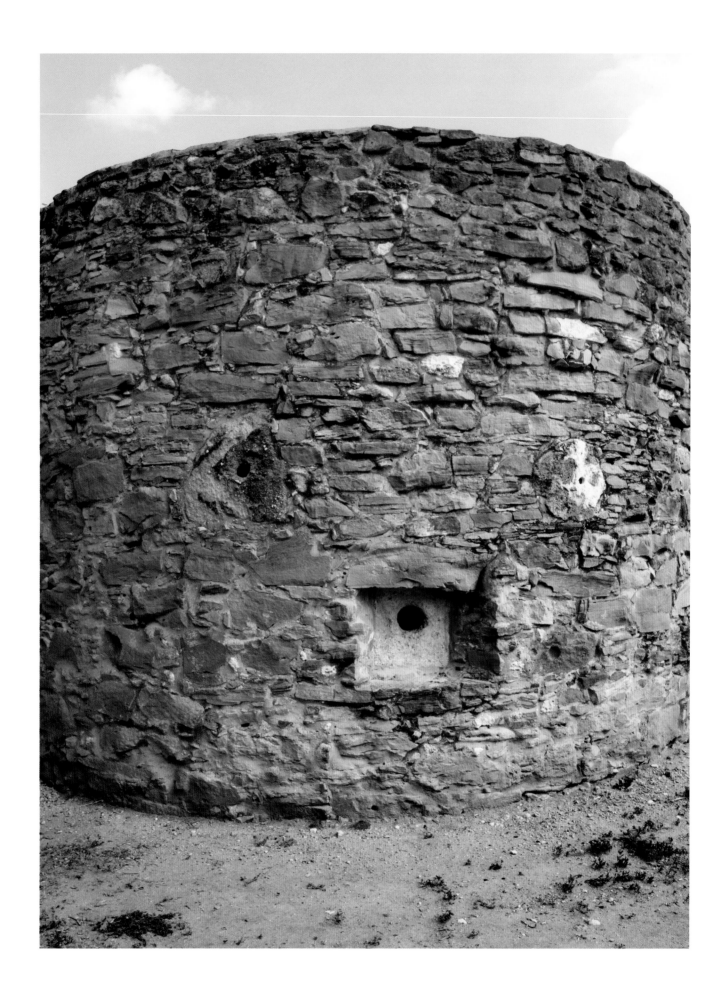

Mexican soldiers sent to defend the isolated Espada community in the 1820s built this defensive bastion at the southeastern corner of the mission plaza's perimeter walls. Nine interior openings for rifles are shown in a composite photo.

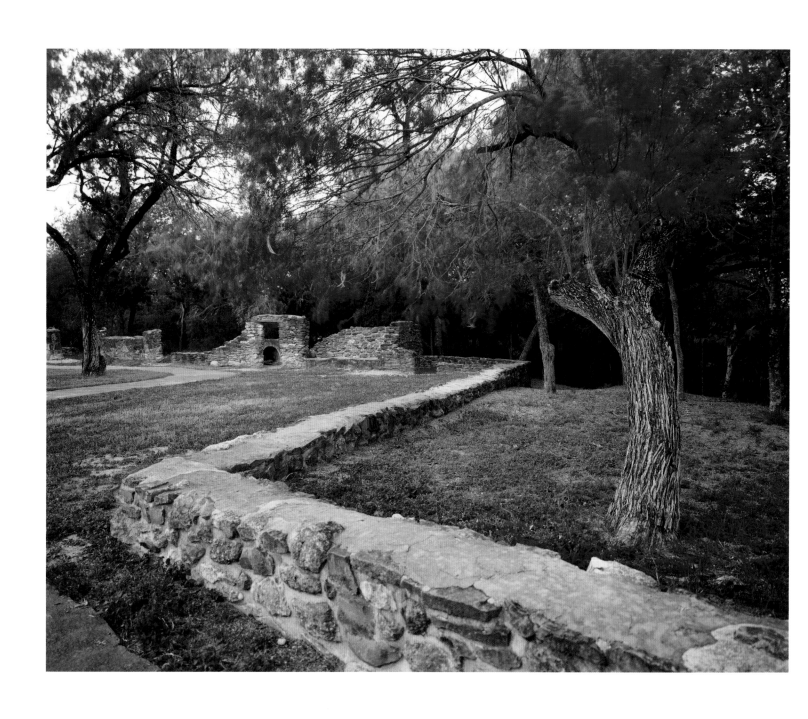

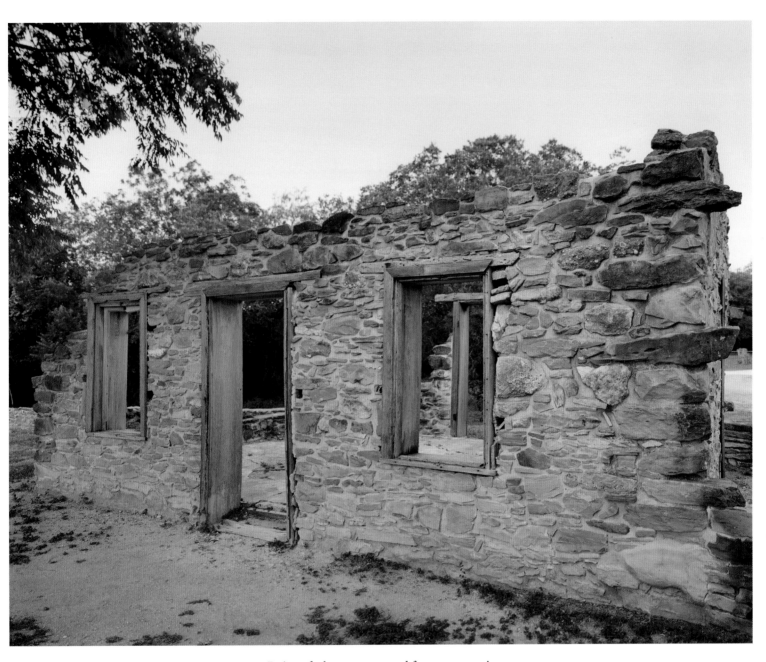

Ruins of a house once used for a community
school are among those preserved beside
remains of Mission Espada's outer walls.

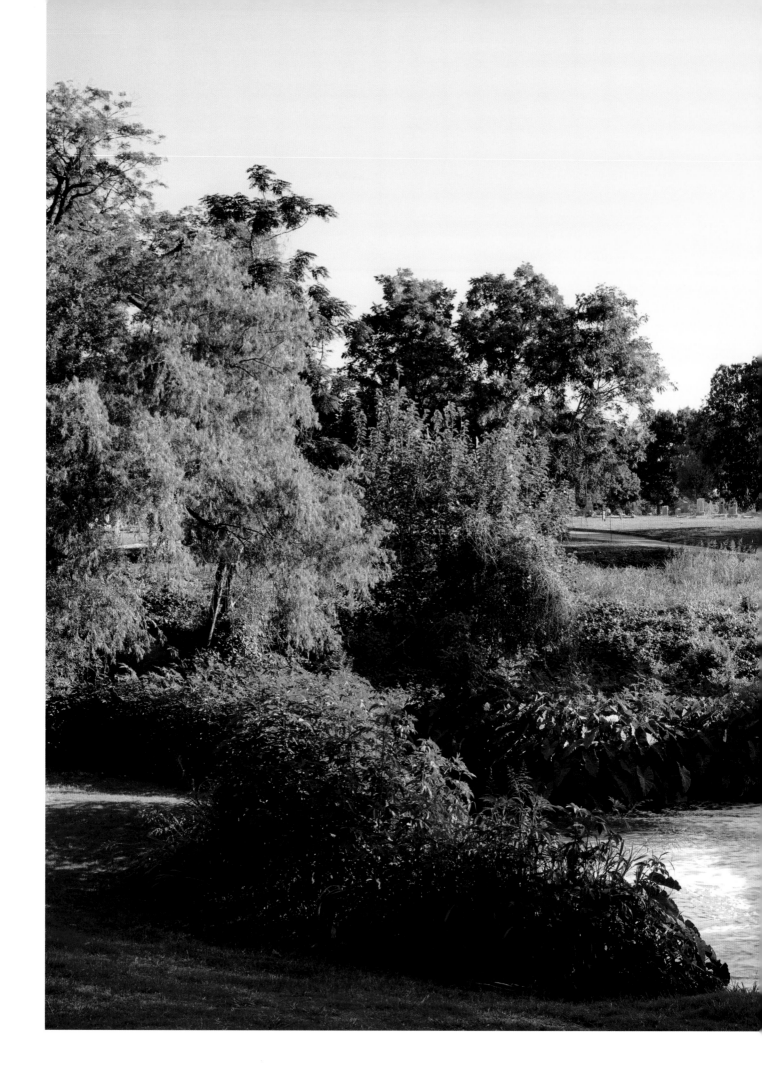

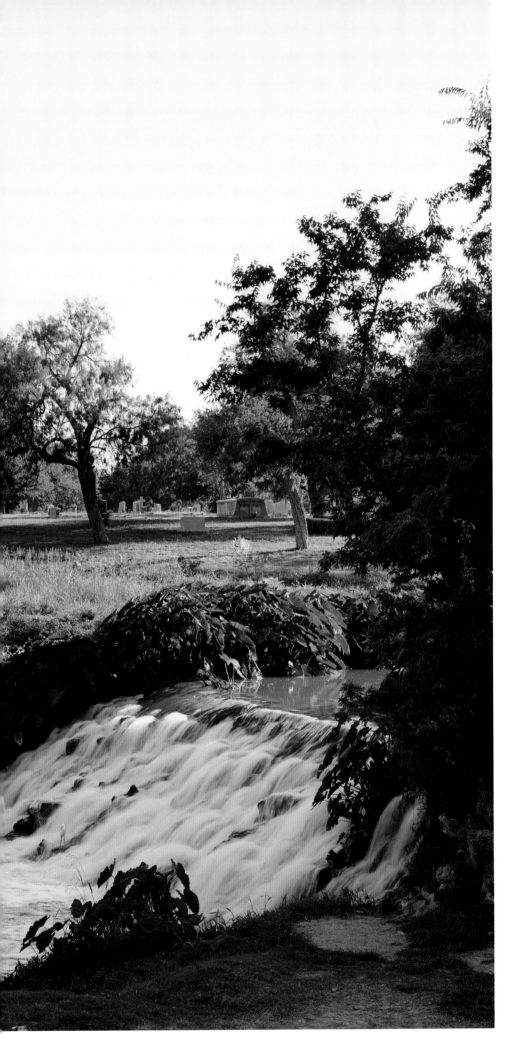

A crane waits for a meal at the base of the original dam for the Mission Espada acequia system, begun in 1731. The wing-shaped dam diverts water held behind it into a narrow acequia channel that follows a gently sloping path to the mission and adjacent fields.

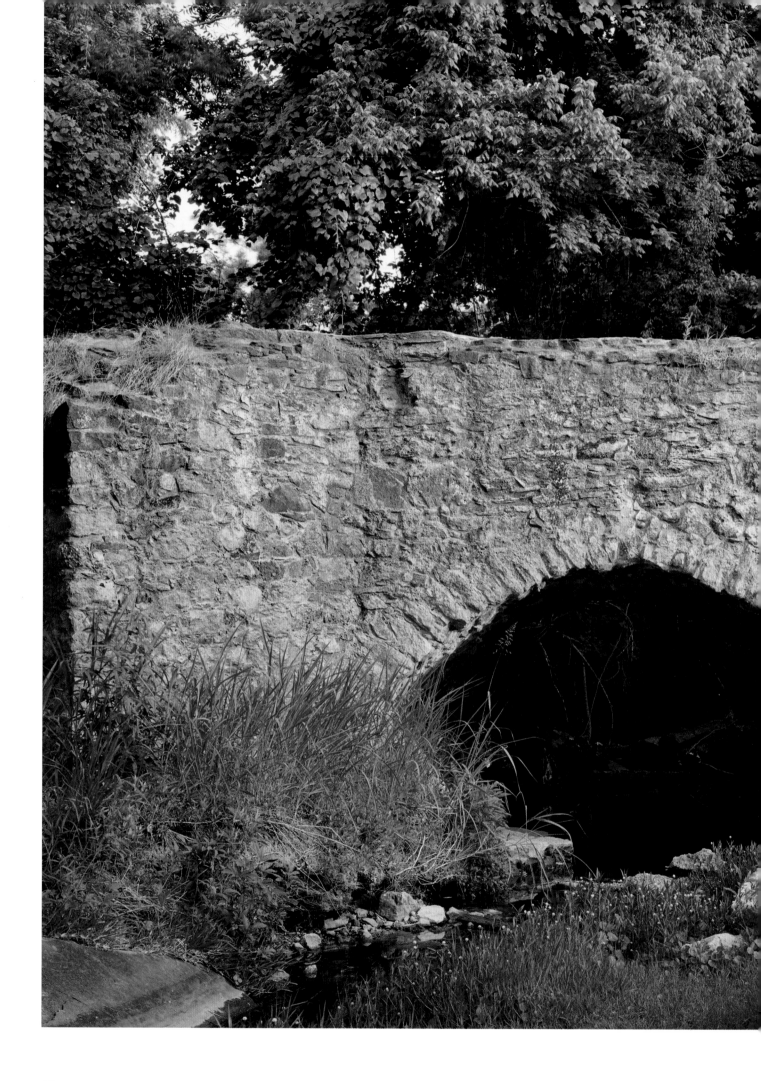

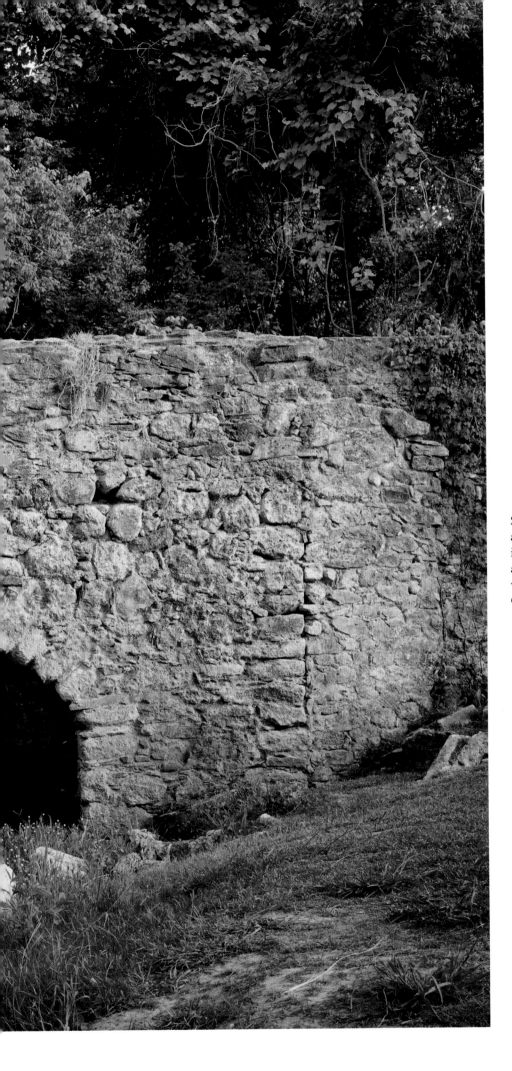

Still carrying Mission Espada's acequia
across the depression of a creek bed
is what has become the oldest stone
aqueduct continuously operating
within the present-day United States.
One of its two arches is shown.

An unusually lush area spreads around
Espada's acequia and aqueduct.

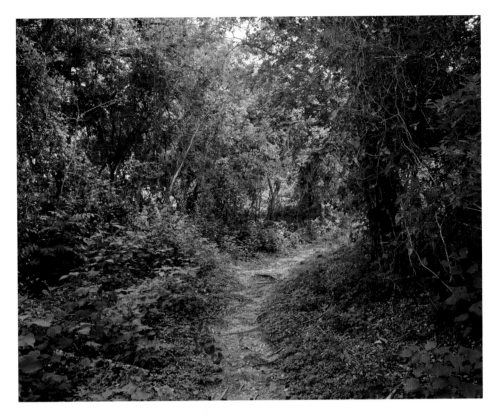

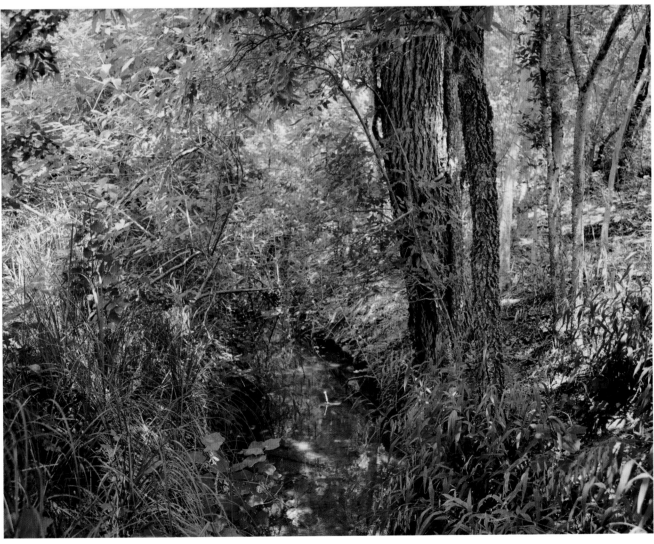

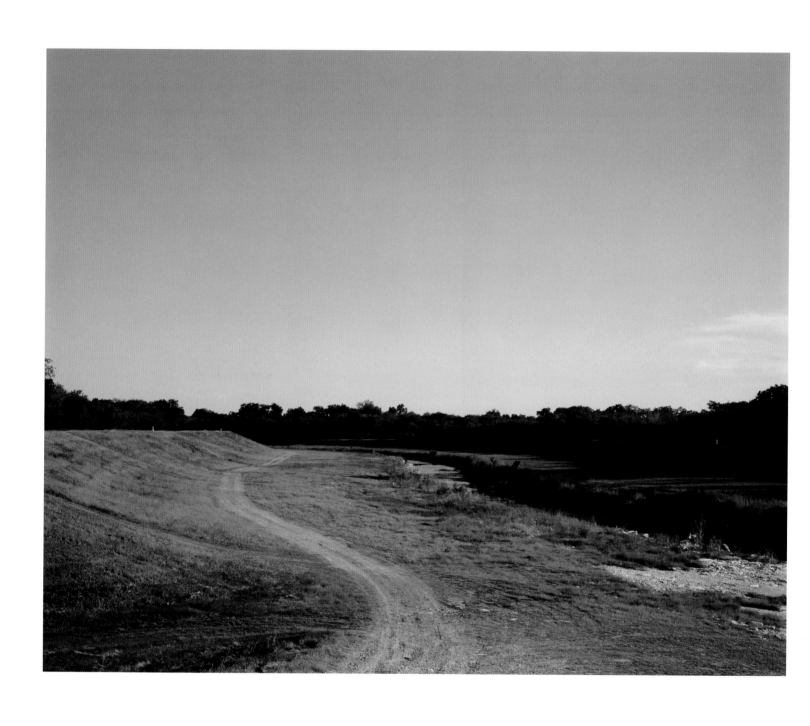

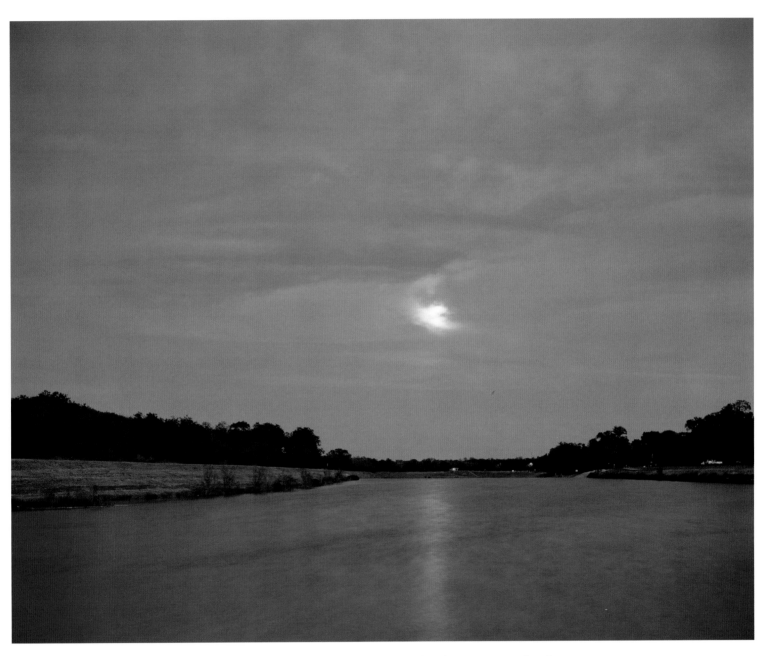

The life-giving course of the San Antonio River was scoured and straightened south of the city in the mid-twentieth century. It is to be restored to an approximation of its original winding path—with plant life and wildlife restored—as part of the recreational Mission Reach extension of San Antonio's River Walk. The moonlit water above is held back by Espada's acequia dam.

San Antonio's southern mission neighborhoods are still home to many descendants of Indians who lived in the original missions. This century-old home is near Mission Espada.